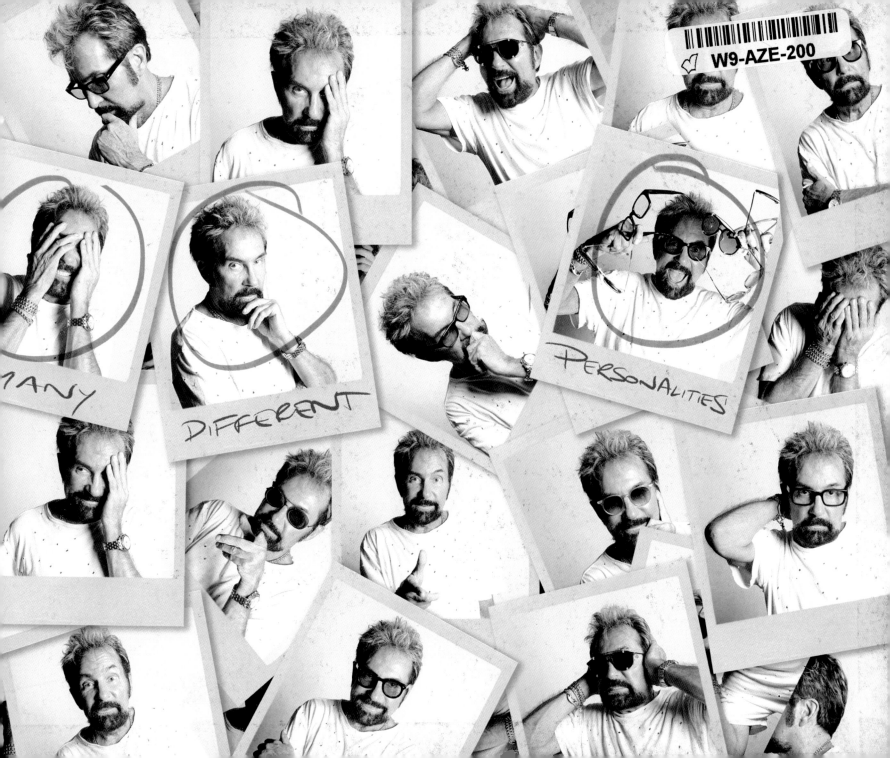

MANY DIFFERENT PERSONALITIES

W9-AZE-200

TONY BROWN

ELVIS, STRAIT, TO JESUS

TONY BROWN

ELVIS, STRAIT, TO JESUS

AN **ICONIC PRODUCER'S** JOURNEY WITH LEGENDS OF
ROCK 'N' ROLL, COUNTRY, & **GOSPEL** MUSIC

CENTER
STREET

NEW YORK | NASHVILLE

Center Street

Hachette Book Group

1290 Avenue of the Americas, New York, NY 10104

centerstreet.com

twitter.com/centerstreet

First Edition: May 2018

Center Street is a division of Hachette Book Group, Inc. The Center Street name and logo are trademarks of Hachette Book Group, Inc.

The publisher is not responsible for websites (or their content) that are not owned by the publisher.

The Hachette Speakers Bureau provides a wide range of authors for speaking events.

To find out more, go to www.HachetteSpeakersBurea.com or call (866) 376-6591.

Print book cover and interior design by Rick Caballo, Dead Horse Branding

Author management by Dead Horse Branding, Melissa Core Caballo and Rick Caballo

www.DeadHorseBranding.com

ISBNs: 978-1-5460-8315-3 (paper over board), 978-1-5460-8314-6 (ebook)

Printed in the Unites States of America

WOR

10 9 8 7 6 5 4 3 2 1

This book is dedicated to
Gary Haber
(1950-2014)

If anyone in my life wore a "white hat," it was Gary Haber.
He gave me the very best business advice, which I profit from to this day!
He was a life advisor to me, and after his passing I realized that I would
actually have to grow up!
Honest, intelligent, and the kindest person I have ever known—
Thank you, Gary, for being at the center of my life and career!

Tony Brown

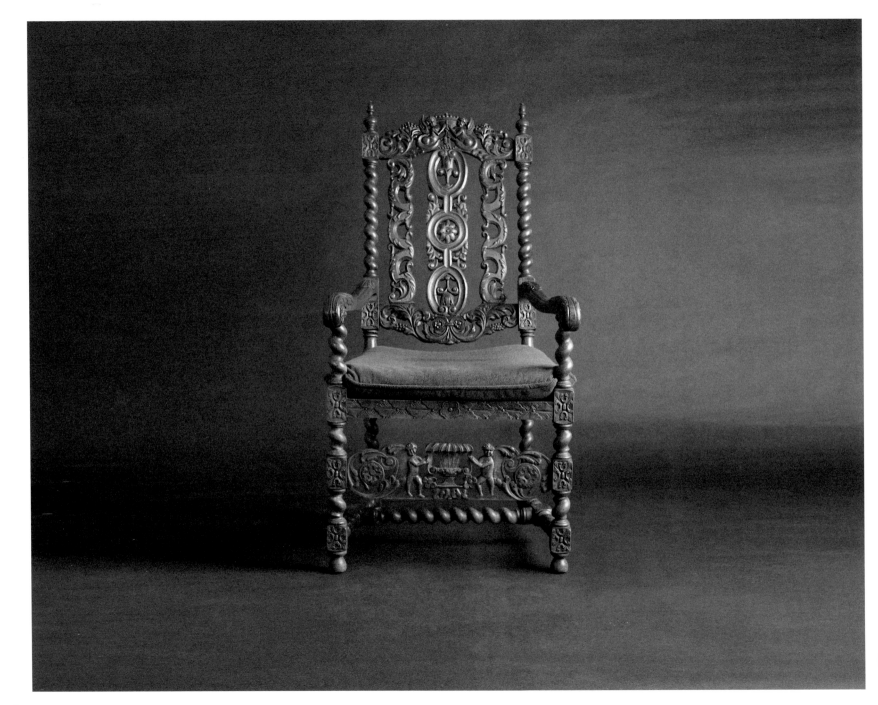

"ICONS AREN'T MANUFACTURED ON AN ASSEMBLY LINE.

THEY **ARE CARVED OUT OF TIME."**

Rick Caballo

CONTENTS

750mm

60mm
DIAMETER

20°

750mm

450mm

¢ 300mm

600mm

SIDE ELEVATION

80mm

500mm

1200mm

250mm

450mm

* HAND CARVED
 CHAIR TO HOUSE
 TONY BROWNS
 FRIENDS

* CONTACT
 KATHY ANDERSON
 ANDERSON DESIGN
 STUDIO

FRONT ELEVATION

600mm

SCALE 1:5

550mm

550mm

TOP ELEVATION

TONY BROWN
COFFEE
TABLE BOOK
PROJECT

2018

FRENCH RENAISSANCE
CHAIR

SKETCH BY
RICK CABALLO

SOFT
COTTON
TWILL
CUSHION

10

FORTY OF MY CLOSEST FRIENDS

AND COLLEAGUES, WHO PLAYED KEY ROLES AT MY LIFE'S PIVOTAL INTERSECTIONS,

TAKE A SEAT IN MY CHAIR AS WE LOOK BACK

ON THE JOURNEY AND CAREER THAT I WAS BLESSED WITH.

Serendipitous moments have happened throughout my life, as it relates to my career trajectory. Much of my journey was not planned, and although I mostly followed my heart, my instincts helped me make some very wise decisions. Pictures sometimes tell this kind of story better than words, which is why I've chosen key people to be featured in my French Renaissance chair. The chair represents me. And those in the chair were present at the intersections where I took a big step, or maybe a subtle right or left turn.

Although my relationships with those featured in this book span years—or even decades—I will introduce you to my friends by naming the year I believe was the most significant in our history.

We all have a destiny, and we can affect it for good, or just stay steady and moving straight ahead. You'll discover that the famous quote by Seneca that says, "Luck is what happens when preparation meets opportunity," definitely applies to my life.

I've really enjoyed putting this book together and feel proud to have such talented and kind friends be a part of my life story. I look forward to the next chapter in my life. I hope you enjoy this one.

Tony Brown

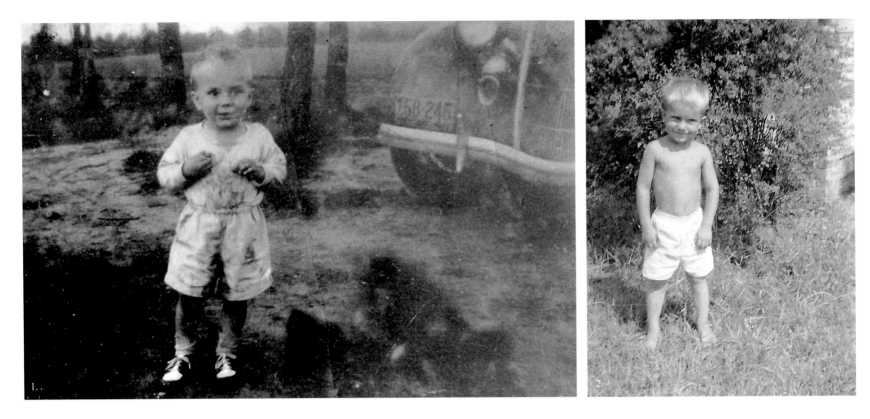

1940s

WE WERE SO POOR IN THOSE DAYS, BUT SOMEHOW I JUST DIDN'T REALIZE IT.

Growing up poor is how I learned humility and that middle class folks were not rich just because they had nice brick homes and fancy cars. They shared the same values as my family but had more shiny things, which they had worked for. We had very little—no indoor plumbing for bathrooms, no TV, a rattletrap car, and lots of our Christmas presents and clothes came from Goodwill. But we did have an old upright piano. And my time spent playing it would serve me very well later on.

My dad became an evangelist after he was diagnosed with lung cancer. We kids would play and sing, and he would preach hellfire and brimstone (an old Southern expression).

In my childhood, I began to analyze how to move up the food chain while remaining humble. I wouldn't change a thing about the way I was raised. My musical ability, cultivated during that time, became my "glass slipper," except I wouldn't lose it!

I love the sentiment of the Ricky Skaggs song "Don't Get Above Your Raisin'." It's kind of funny, but it's the way blue-collar Southern folks thought about things. And it's the way I still think about things.

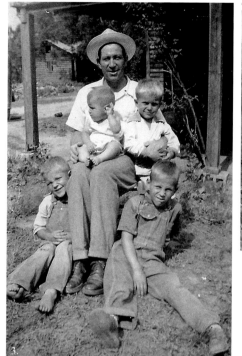

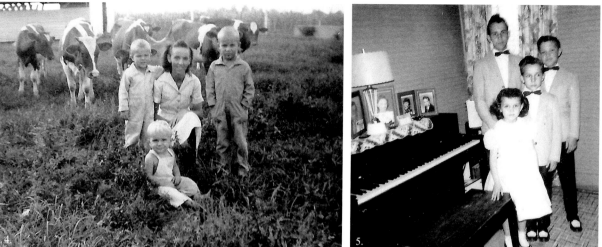

1. Me in front of Dad's car in Greensboro, North Carolina.
2. Me in front of our house in Greensboro.
3. Me with Dad, my brothers, and my sister in Elkin, North Carolina, at my grandmother's house (I'm first to Dad's right).
4. Me (center), Mom, and my brothers on our dairy farm in Greensboro.
5. Me (second to right), my brothers, and my sister dressed up for church in Walkertown, North Carolina.
6. Grandma Brown, Dad, and all my aunts in Winston-Salem, North Carolina.
7. Me, Mom, and my sister at home in Walkertown.

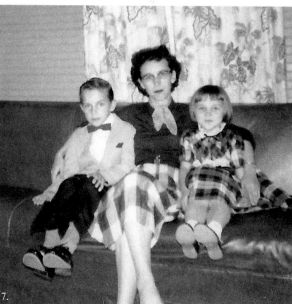

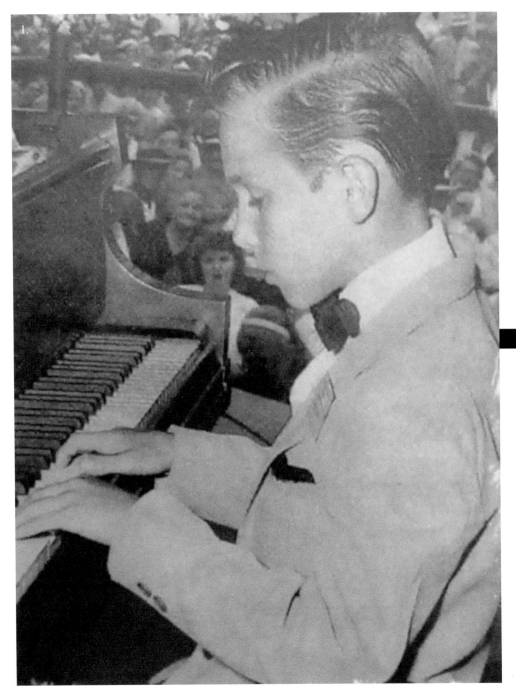

1950s

When I was thirteen, I played piano in my first live performance as part of The Brown Family Singers at the annual Southern Gospel Music Festival in Benson, North Carolina (photo left). My feet barely touched the pedals. The crowd's big response to my confidence, despite my small stature, caused me to catch the bug for being in showbiz. I played the song "All the Way" in the key of F. It was the only song I knew but I could play the hell out of it!

1. Me at my first performance at the Southern Gospel Music Festival in Benson.
2. Me, Mom, and my aunts at a family gathering in Winston-Salem.
3. Swimming in Monroe, Louisiana.

3.

MY FATHER WAS A STRICT EVANGELIST.
I WAS ONLY ALLOWED TO LISTEN TO GOSPEL MUSIC.

1950s-1960s

The Brown Family Singers would become a musical sensation. We were a very close family, and life revolved around music and all things church. We didn't have much money but excelled because of the fun and love that surrounded us.

I left home at fourteen years of age to live with two other families that had gospel singing groups. That's when I experienced middle-class life. These families lived in brick houses and drove brand-new cars. Getting a taste of their lifestyle made me feel rich, and it gave me the drive and desire to rise to that level of living.

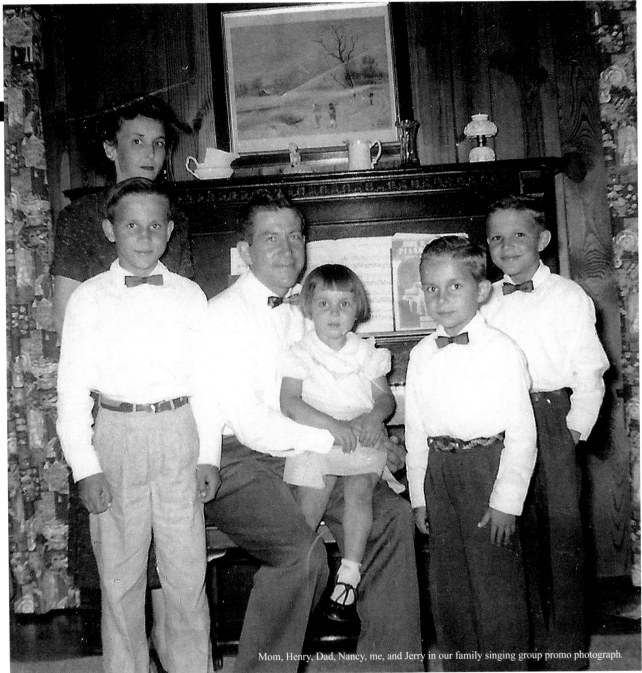

Mom, Henry, Dad, Nancy, me, and Jerry in our family singing group promo photograph.

MY EVANGELIST FATHER AND PLAYING CHURCH REVIVALS

Because we weren't necessarily affiliated with one particular denomination—although I think we kind of called ourselves Baptists—my dad preached and we sang at all kinds of evangelical churches and their revivals. That included Baptist, Methodist, Moravian, Salvation Army, Church of God, Assembly of God, Nazarene, Holiness, and churches from different branches of those denominations.

We also sang and preached in black churches. Those had the best music and I took notice. Also, Pentecostal churches always had great music.

Every day of every week was about church for the Brown family. There was Sunday morning service and Sunday night service. On Mondays, we visited people's homes to invite them to church. Tuesday nights we went to the old folks' home to sing to all of the shut-ins. On Wednesdays, we had prayer meeting at the church. Then Thursdays we either had Bible study at someone's home or some church hosted Dad to preach. Friday nights were usually times for gospel singings, or concerts we held with other Southern gospel groups. Saturday nights were like Friday nights—we'd hit other towns to perform with different gospel music groups.

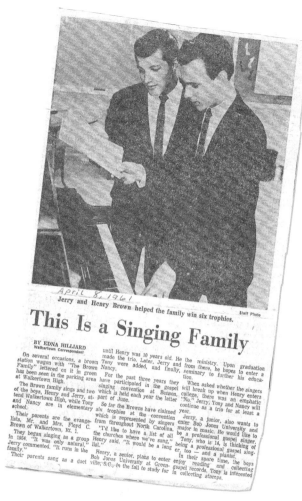

April 8, 1961

Jerry and Henry Brown helped the family win six trophies.

This Is a Singing Family

BY EDNA HILLIARD
Walkertown Correspondent

On several occasions, a brown station wagon with "The Brown Family" lettered on it in green has been seen in the parking area at Walkertown High.

The Brown family sings and two of the boys, Henry and Jerry, attend Walkertown High, while Tony and Nancy are in elementary school.

Their parents are the evangelists, Mr. and Mrs. Floyd C. Brown of Walkertown, Rt. 1.

They began singing as a group in 1954. "It was only natural," Jerry commented. "It runs in the family."

Their parents sang as a duet

until Henry was 10 years old. He made the trio. Later, Jerry and Tony were added, and finally, Nancy.

For the past three years they have participated in the gospel singing convention at Benson, which is held each year the latter part of June.

So far the Browns have claimed six trophies at the convention which is represented by singers from throughout North Carolina.

"I'd like to have a list of all the churches where we've sung," Jerry said. "It would be a long list."

Henry, a senior, plans to enter Bob Jones University at Greenville, S.C., in the fall to study for

the ministry. Upon graduation from there, he hopes to enter a seminary to further his education.

When asked whether the singers will break up when Henry enters college, there was an emphatic "No." Jerry, Tony and Nancy will continue as a trio for at least a year.

Jerry, a junior, also wants to enter Bob Jones University and major in music. He would like to be a professional gospel singer.

Tony, who is 14, is thinking of being a professional gospel singer, too — and a pianist.

In their spare time, the boys enjoy reading and collecting gospel records. Tony is interested in collecting stamps.

MY MUSICAL FAMILY

Dad was a musical evangelist, who originally played piano for The Brown Family Singers while my two brothers, my sister, and I sang together as a quartet. My brothers, Jerry and Henry, were featured up front as the main singers while my sister, Nancy, and I covered the harmony parts. After singing in the group awhile, I eventually learned to play the piano and was given the opportunity to play on one song during our shows. It became a highlight of our service. I was small in stature and there was a lot of excitement when I played. Needless to say, it made an impression on me. I later talked the family into letting me play two songs at every service. It was a hit. My future was sealed at that point, and the rest is history.

Walkertown newspaper clipping featuring The Brown Family Singers.

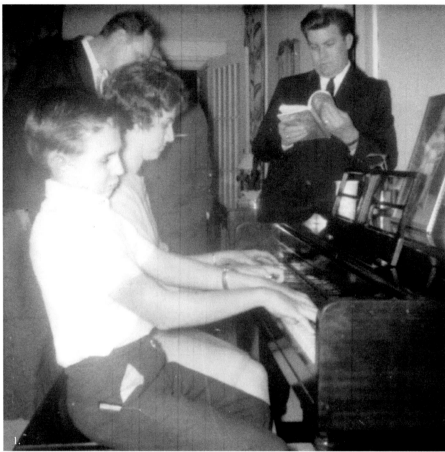

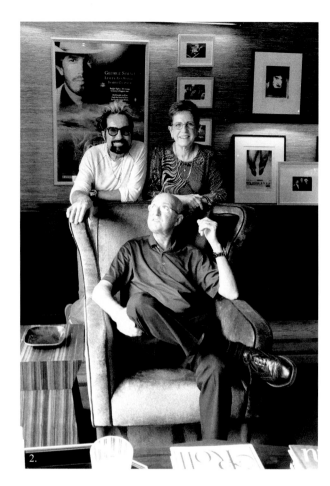

1960s

MOVING IN WITH MY PIANO TEACHER

Once I was playing piano on two songs at every service, my dad realized that I had talent. He put me on a bus and sent me to a six-week gospel music camp in Dallas, Texas. It was called The Stamps Quartet School of Music. They strictly taught the Southern gospel style of singing and playing, which in those days looked like four singers around one piano player.

Linda Robinson was my teacher there, and months after camp ended, she persuaded my dad to let me move in with her family who were a gospel singing group in Bastrop, Louisiana. The catch was that, in exchange for free board and piano lessons, I would play in their group. Linda encouraged me to expand my ability to play by ear since I could not read music. It literally changed my life. My brothers had learned to read music and I had not, which had always made me feel like a failure—until I met Linda and got a boost in my confidence. I can thank my dad for pushing me to do that.

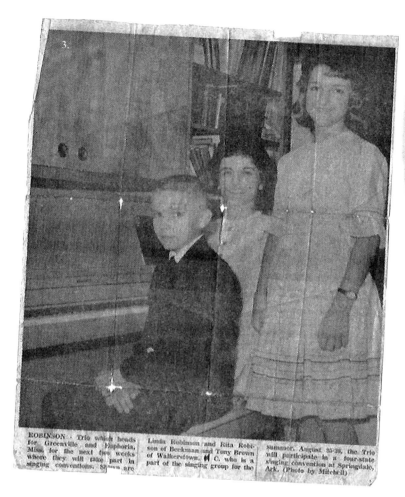

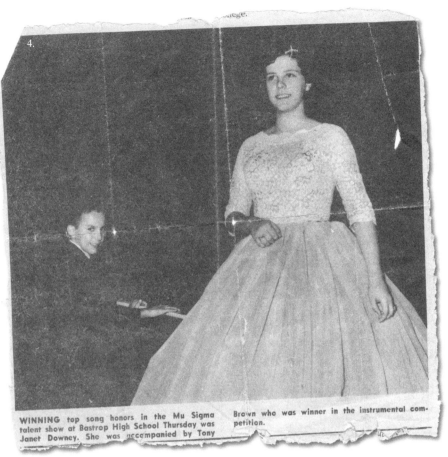

I LEARNED TO GROW UP FAST WHILE AWAY FROM HOME

Being away from home from a young age helped me grow up fast. Playing with Linda's groups also offered me a lot of experience onstage and helped lay the groundwork for my career backing some of music's greatest performers.

1. Linda Robinson showing me some new licks at her home in Bastrop, Louisiana.
2. Linda Robinson and her brother, Danny, at my home in Nashville in 2017.
3. Me, Linda Robinson, and Rita Robinson of the Robinson Family Singers featured in a Bastrop newspaper.
4. Janet Downey and I at a talent show at Bastrop High School. We won the contest that night and were featured in a Bastrop newspaper.

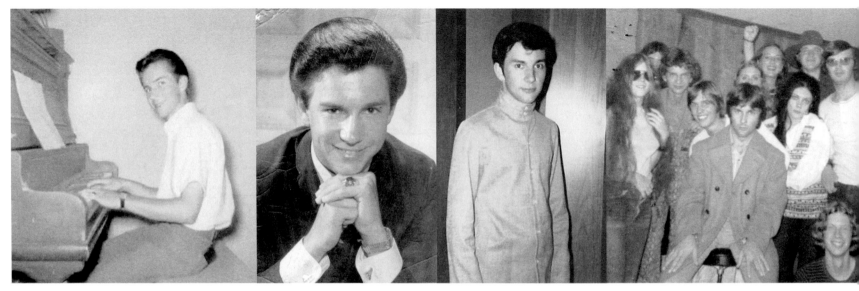

1960s and 1970s
HOW MUSIC IMPACTED MY LIFE

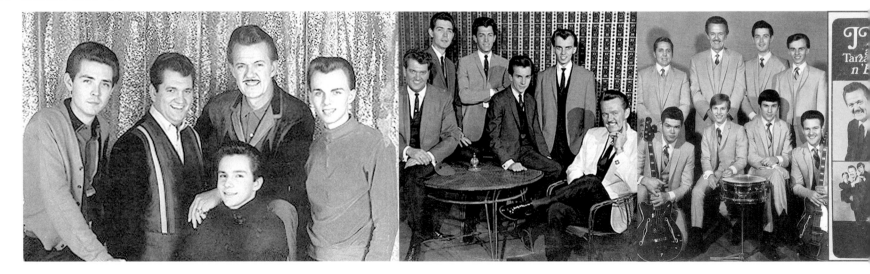

I never wanted to be a star, I just wanted to be noticed. Even as a kid playing in my family's group, I realized that the moments in our shows when I was featured were opportunities to gain recognition. That drove me to not only try to play the piano better but to try to learn the art of entertainment. And while I stayed with my teacher Linda Robinson, I was exposed to a lot of entertainers who would have an impact on me. Unlike my family, the Robinsons had a TV and I got to watch variety shows, featuring acts like Glenn Campbell, the Mandrell sisters, Dean Martin, and Red Skelton. I began to realize how much Vaudeville antics played a part in entertainment and started to add elements of it to my performances. I continued to develop those skills while I played for J.D. Sumner & the Stamps Quartet. During that time, I got the ironic nickname "Tarzan" and made the most of it, to the enjoyment of our fans. J.D. and I went on to do a record together called J.D. and Tarzan n' Em: Humor in Concert (BMG Records, 1970), in which we highlighted the funny shtick we used onstage. It was a riot. I also performed on other records with J.D. & the Stamps.

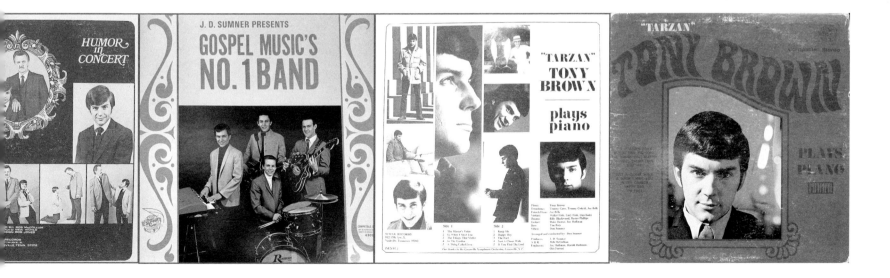

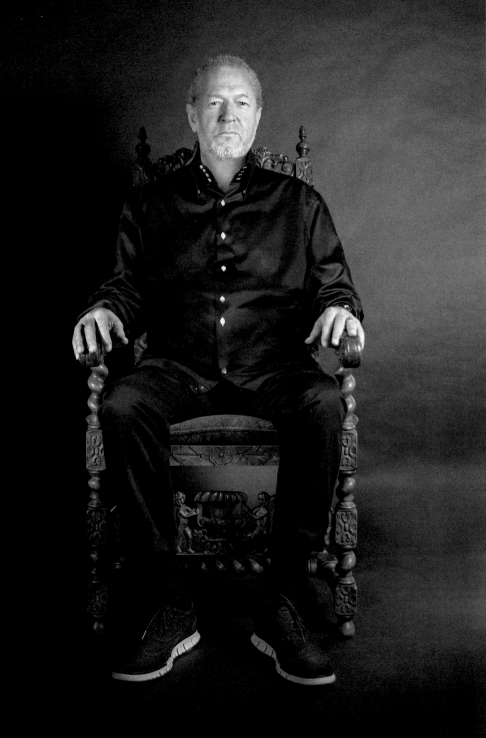

1968

I first met Mylon LeFevre in 1968 when we were playing in a band behind J.D. Sumner & the Stamps Quartet. We were roommates while we were both single and I became awed by Mylon's "coolness" and hip style. Back then, Mylon wrote a song called "Without Him," which Elvis recorded. Needless to say, he was someone I really wanted to be like. He influenced my style—not only in music but even in the way I dress to this day.

Mylon's forward thinking in fashion drove him outside to the Jesus Rock movement in California, which was not acceptable to those in the Southern gospel music circles. And you needed to be in that circle.

Years later, Mylon reentered the gospel music world through the contemporary Christian music scene, which had become a mainstream genre just like Southern gospel.

Mylon now travels with his wife, Christi, ministering and teaching across the country. He has let go of the drugs and rock 'n' roll lifestyle but still has a Harley and a cool persona.

"Sometimes it takes a while to find out what money can't buy and what's really important in life. I'm really proud of you, Tony; you didn't quit when it got hard."

Mylon LeFevre

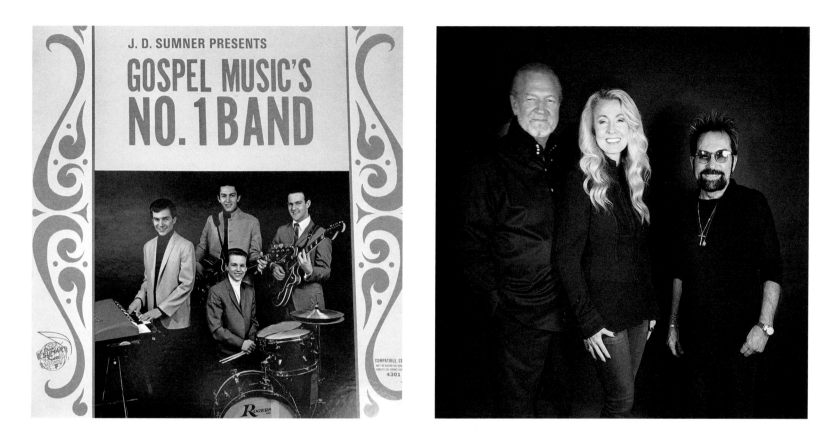

FASHION IS FOR PEOPLE WHO DON'T HAVE STYLE. THAT **WAS NEVER A PROBLEM FOR MYLON.**

1969

Donnie Sumner is the talented nephew of singer J.D. Sumner. I think the first big influence in my life in every way possible was "the world's lowest bass singer," J.D. Sumner! Not only did he influence me but he gave me my first professional job as a musician.

First of all, growing up on Southern gospel music, J.D. was the biggest superstar of all in the genre. He sang bass with RCA recording artists the Blackwood Brothers Quartet. J.D. left the Blackwood Brothers to form his own group called J.D. Sumner & the Stamps Quartet. It was then that J.D. hired me, along with his nephew, Donnie Sumner.

After I had left the group to go work with the Oak Ridge Boys, J.D. & the Stamps would go on to tour with Elvis Presley. Donnie and J.D. always had a rivalry, and eventually J.D. fired Donnie from the Stamps. Elvis worshiped J.D. but he loved Donnie Sumner's voice. So, Elvis had Donnie form the group The Voice to sing around his houses—in Beverly Hills, Palm Springs, Graceland in Memphis, or wherever Elvis might be in his off time. Donnie soon hired me to play piano for The Voice. That is how I was introduced to Elvis's team. The Voice would open up shows for Elvis, and then during Elvis's concert I would sit behind pianist Glen D. Hardin, from the TCB (Taking Care of Business) band, to watch him play the piano.

I fostered a relationship with Elvis's TCB Band and eventually replaced Glen D. Hardin when he left to play with Emmylou Harris full time. Because of Donnie and J.D. Sumner, I was able to play with the King of Rock 'n' Roll. Thank you, Donnie, my brother! That changed everything!

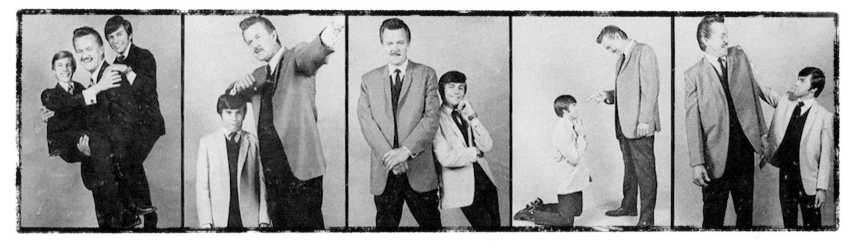

J.D. SUMNER THE BAD ASS BASS

"The only thing better than receiving praise is deserving it."
J.D. Sumner

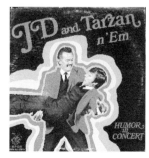

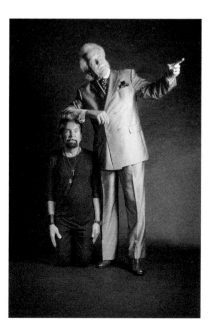

**"A man is rich
who has a friend."**
Donnie Sumner

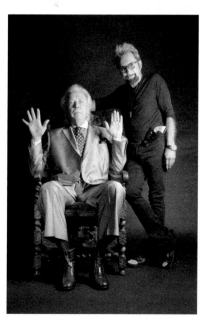

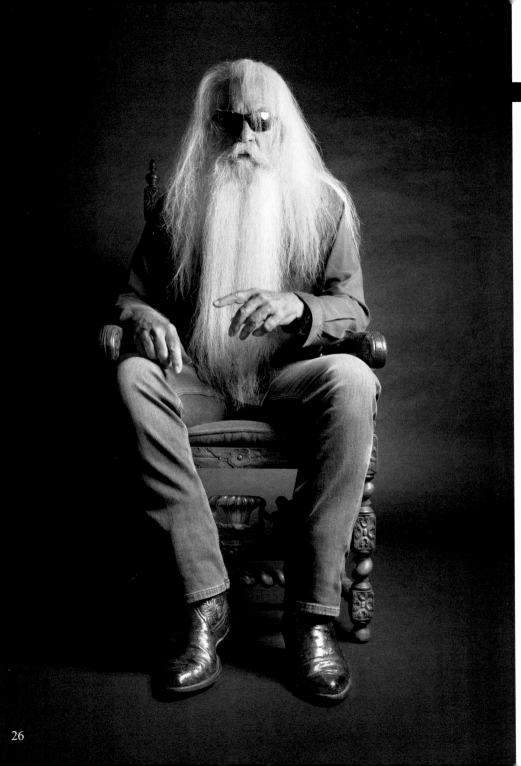

1972

I joined the Oak Ridge Boys in 1972 and it would change my life in many ways. Back when I first met William Lee Golden, the baritone singer for the Oak Ridge Boys, I thought he was the most charismatic person I had encountered since J.D. Sumner. People like William always influence the way you live your life whether you realize it or not.

Playing with the ORB was a wonderful education for me, as a musician and in terms of how an artist's image plays a role in entertainment. William is a "fashionista" of the biggest sort. He helped me to realize that how you present yourself can give you an edge, especially in the music business. I remember that when I first met him, he was in his Warren Beatty/*GQ* phase. Over the years his look morphed into what it is today. He looks like a "wise man," and just for the record…he is!

Of all the ORB members, William is the one I have stayed close with all these years. We relate on a lot of levels, from musical taste to the meaning of life. Love the guy!

The Oak Ridge Boys have sold over 40 million records (RIAA).
Forty-five years after forming, they are still performing.

**"I've been a fan and friend of Tony's since the day I saw him.
He was a sixteen-year old boy sitting on telephone books while playing the piano with the Dixie Melody Boys Quartet."**

William Lee Golden

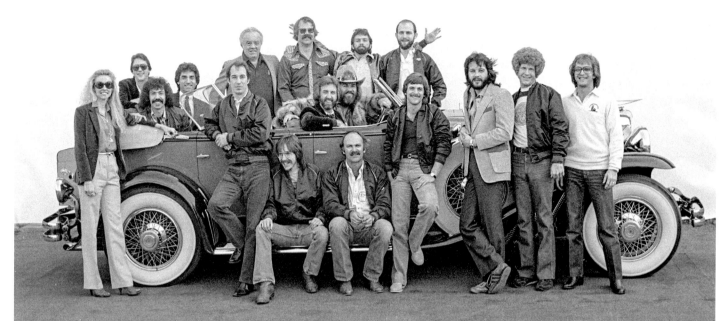

Oak Ridge Boys *Fancy Free* album cover shoot (1979).

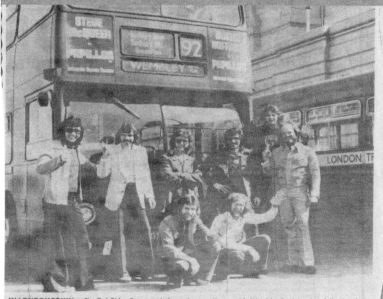

IN LONDON TOWN — The Oak Ridge Boys pose in front of an omnibus outside Wembley Pool, London, following their appearance at the Country Music Festival April 13-14. From all news accounts, the audience was greatly pleased with the Oaks performance and many country stars added a gospel number to their program during the two-day event. The Oaks are expected back for next year's festival. They are (from left) Bill Golden, Joe Bonsall, Duane Allen, Richard Sterban, Don Breland and John Rich while in front are Tony Brown (left) and Mark Ellerbee.

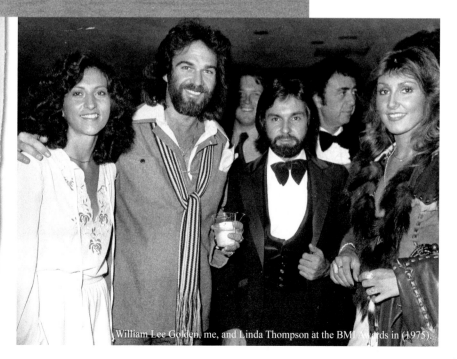

William Lee Golden, me, and Linda Thompson at the BMI Awards in (1975).

BILL CARTER

Bill Carter became my attorney in the winter of 1983. That was when the rumor that Jimmy Bowen was taking over MCA Nashville was circulating around town.

Bill secured me a job as the head of A&R (Artist and Repertoire) at MCA under Jimmy Bowen on March 12, 1984, which became one of the most life-changing moments in my career. Bill would help me keep that job later on, as rumors swirled that I might be "out" at MCA. A trip to New York City for a meeting with Al Teller, which was secretly set up by Bill, would resolve the crisis. I would go on to stay at MCA Nashville for twenty-five years.

Bill also arranged for me to produce my very first gold record on CBS Nashville for Rodney Crowell, who he was managing at the time. Rodney's *Diamonds & Dirt* was my first big success as a record producer! Besides being my attorney, Bill has also represented many big-name artists, such as the Rolling Stones and David Bowie.

An interesting fact: Before becoming an entertainment attorney, Bill was a Secret Service agent for John F. Kennedy and Lyndon B. Johnson. Bill played a very pivotal role in my life, for sure. Bill wrote a book called *Get Carter*—I did, and I'm grateful for it.

"It was truly an honor to have been an advocate for Tony Brown throughout his career."

Bill Carter

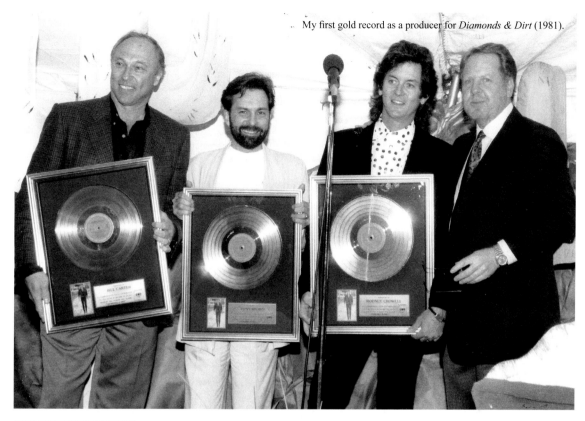

My first gold record as a producer for *Diamonds & Dirt* (1981).

BILL WROTE A BOOK CALLED **GET CARTER** - I'M SO GLAD I DID!

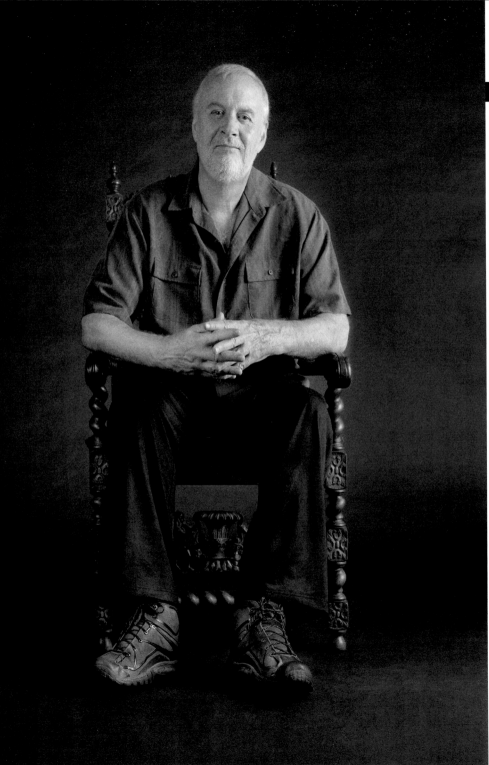

1975

DAVID BRIGGS

My relationship with David Briggs is one that would propel my career beyond my wildest dreams. When I came to Nashville in 1967, there was one main rhythm section that played on about 90 percent of all records recorded here. They were called the "A-Team." David was one of those guys. He was the most sought-after keyboard session player in Nashville for many years, and his long list of credits would not fit in this book.

David and I ended up playing together in Elvis's TCB Band in 1975. He played electric keyboard and I played acoustic piano. After Elvis's death, David recommended me to replace Glen D. Hardin in Emmylou Harris's The Hot Band, and for all of the band opportunities that followed, including backing Rodney Crowell, Rosanne Cash, and The Cherry Bombs. David also single-handedly got me my first A&R gig with Jerry Bradley at RCA Nashville, which then led to my job at MCA, and the rest is history!

This friendship may be one of the most important of my life. David is an awesome musician and arranger, but he's the best friend a guy in my position could have ever had!

Thank you, David Briggs!

"Tony Brown is one of the best musicians, producers, and all-around talented guys in the music business. I would trust him on any project."

David Briggs

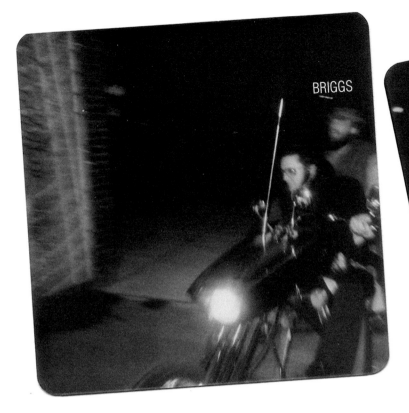

BRIGGS

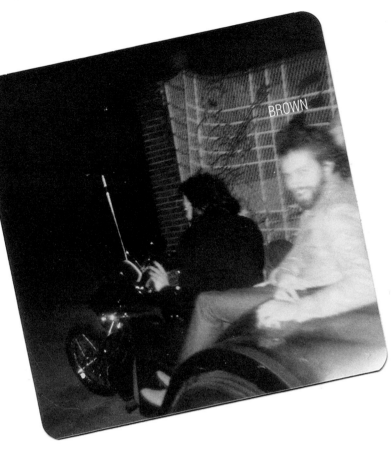

BROWN

ELVIS SHUT DOWN A RECORDING SESSION AND TOOK BRIGGS AND ME OUT THE GATES OF GRACELAND ON HIS BRAND-NEW TRIKE.

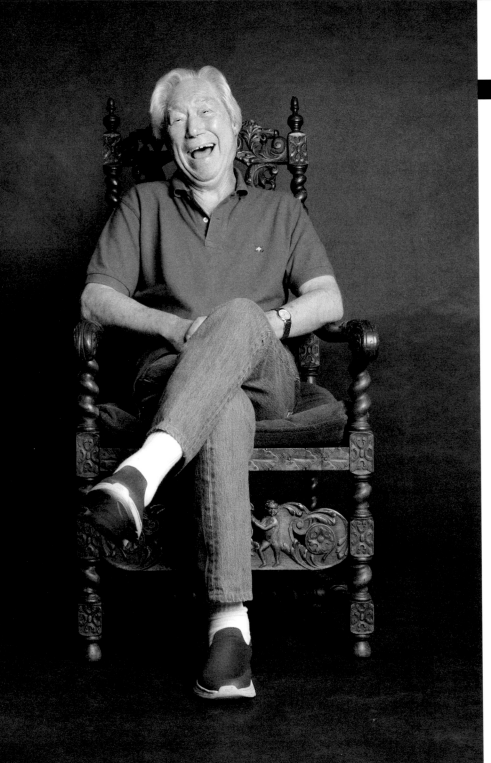

1975

Glen D. Hardin was Elvis's piano player when I was playing behind the singing group The Voice, who was opening up for Elvis on tour. I sat behind him as he accompanied Elvis during my first year with the tour. I replaced Glen D. in the TCB Band when he left to go on a world tour with Emmylou Harris.

In 1977, I once again replaced Glen D. when he left Emmylou to tour with John Denver. We played a lot alike, and I would say that, in a way, he was a mentor to me, just by coincidence.

Thank you, Glen D. Hardin.

**"Oh Rock,
I have felt the sting of thy terrible swift sword upon my fevered brow, and I care not, for when the great conductor comes to count those who reneged, He writes not what it payed but how you played the gig."**
William Shakespears

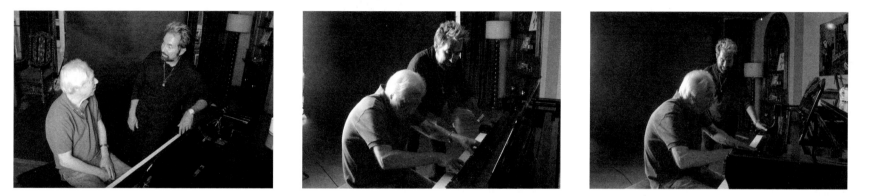

LIVING IN GLEN'S SHADOW REALLY `SHINED A LIGHT` ON ME.

HE WAS THE MOST BEAUT

NO MATTER HOW MUCH SUCCESS I'VE HAD AS A RECORD PRODUCER OR LABEL

IFUL HUMAN I'D EVER SEEN!

EXECUTIVE, IT SEEMS THAT PLAYING WITH ELVIS DEFINES MY CAREER.

Tony Brown

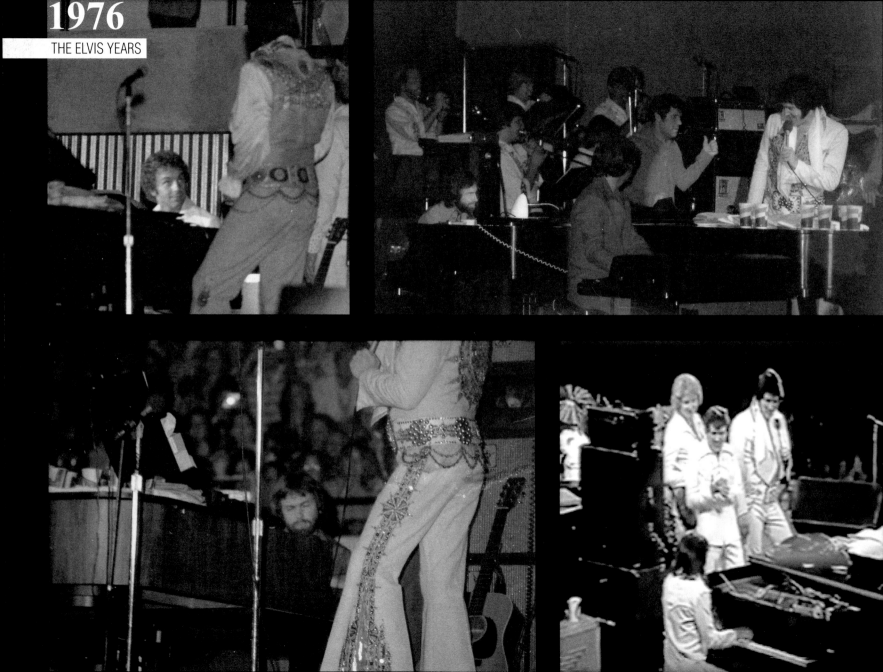

That time of the night when Elvis would always kick me off the piano to play "Unchained Melody."

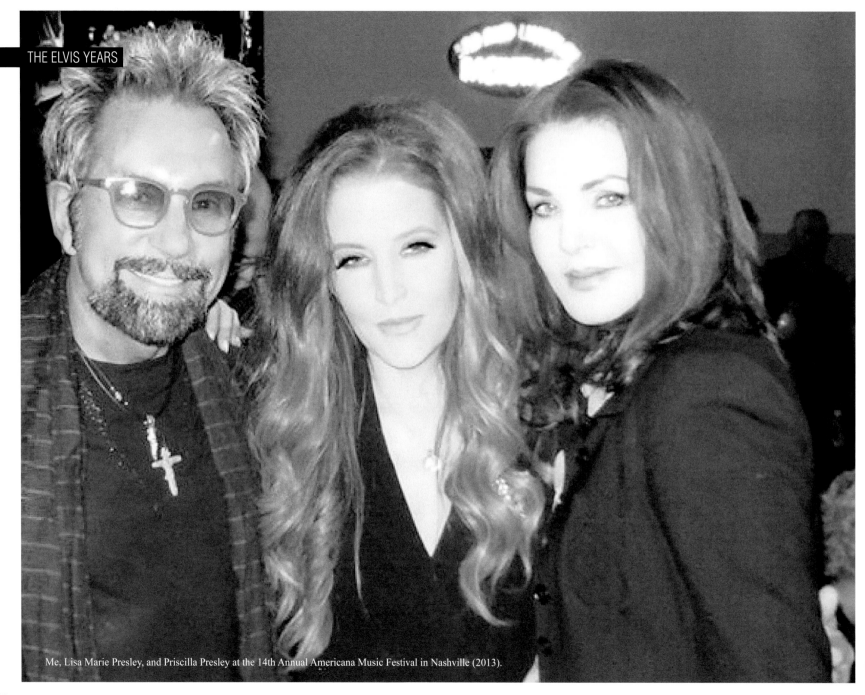

Me, Lisa Marie Presley, and Priscilla Presley at the 14th Annual Americana Music Festival in Nashville (2013).

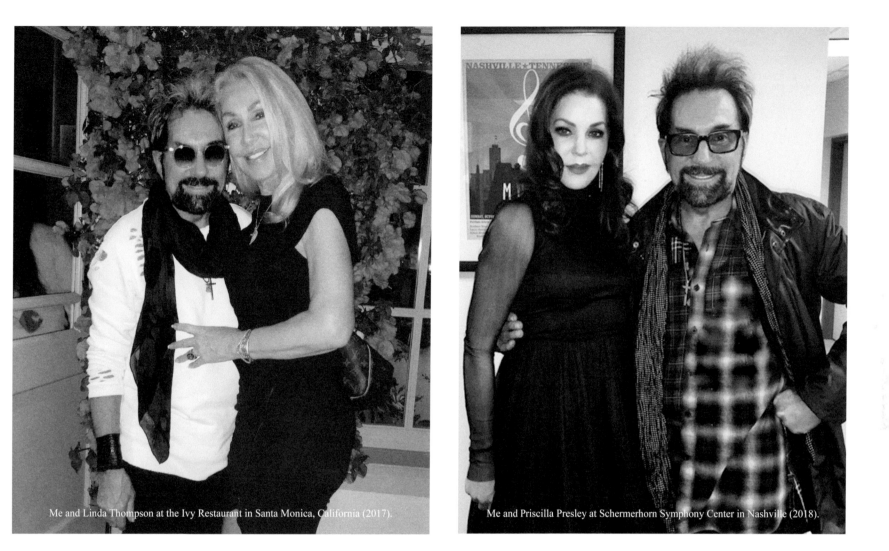

Me and Linda Thompson at the Ivy Restaurant in Santa Monica, California (2017).

Me and Priscilla Presley at Schermerhorn Symphony Center in Nashville (2018).

"Tony Brown was not only a dynamic talent on stage with Elvis, he was a valued friend to us as well in all our years together. Tony was always upbeat, and Elvis and I enjoyed his humor both on the road and at Graceland. I am grateful to call Tony my treasured friend still today." *Linda Thompson*

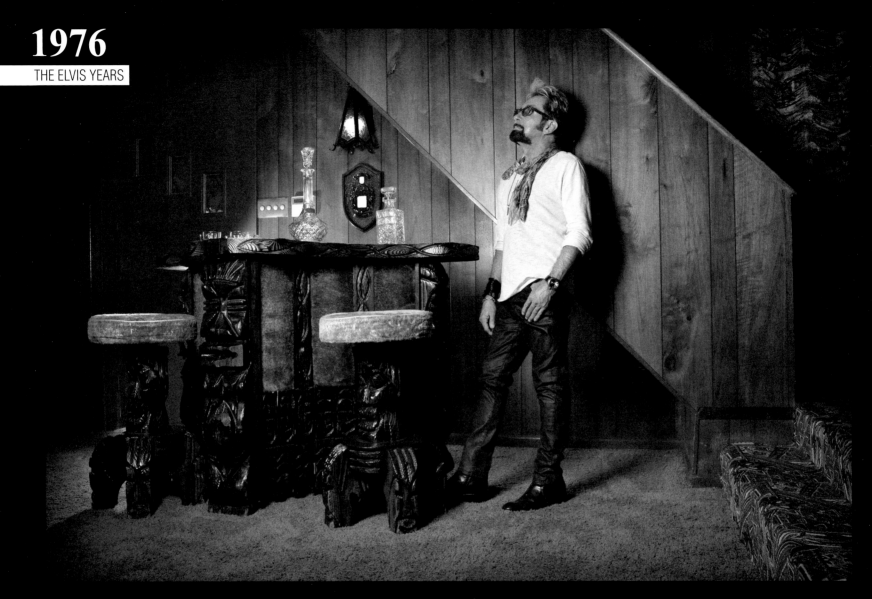

WAY DOWN IN THE JUNGLE ROOM While recording his album _Way Down_ in the Jungle Room in 1976, Elvis stood by the piano while I played the boogie-woogie on the low bass notes. His hand was almost on the keys. We recorded the song "Way Down" in the Jungle Room. This was Elvis's last number one studio single. Between my grand piano and Ronnie Tutt's drums, it was really cramped in there, but Elvis still managed to walk around the room singing and unfazed. In 2016, I visited Graceland and the Jungle Room for the first time in thirty-nine years, and it brought back some fun memories.

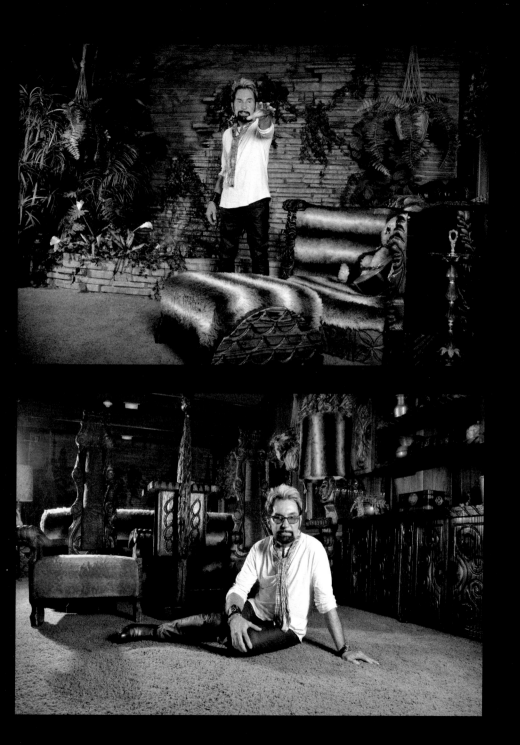

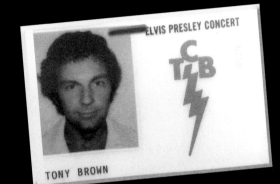

ELVIS PRESLEY CONCERT

TONY BROWN

WALKING IN MEMPHIS:
IN 2016, I VISITED GRACELAND FOR THE FIRST TIME SINCE 1976.

1977

On the morning of August 16, 1977, I was waiting
for the TCB Band airplane to pick up me and other
musicians for a show. We were headed to Portland,
Maine, for the first concert of Elvis's new tour.
Suddenly, the tour management told us to go home
with no explanation as to why.

While heading home in my car, I heard
on the radio that Elvis had been found dead in the
bathroom of his upstairs bedroom at Graceland. I
nearly drove off the road after hearing this news.
The irony is that just a few nights before, I had
been sitting with David Briggs, discussing the
book the Memphis Mafia had just released called
Elvis: What Happened?. Considering the release
of this salacious look into the early years of Elvis's
private life, I had told David, "This is gonna kill
Elvis!" Ironic to that discussion or not, the loss of
this legend is still very sad to me.

The photograph on the right was taken on June 26,
1977, at the Market Square Arena in Indianapolis,
Indiana. It was Elvis's last concert. Of course,
it was another sold-out show and subject to the
frenzy that always accompanied Elvis's concerts.
I will never forget it, and my memories are
bittersweet.

Elvis's last show was one of the few that
drummer Ronnie Tutt didn't play. His spot was
filled by The Cherry Bombs' drummer, Larrie
London. Larrie was the only drummer who could
have filled Ronnie's spot—such a great musician
he is—and Elvis knew that!

NO ONE HAS EVER SHAPED POP CULTURE AS MUCH AS ELVIS DID.
Tony Brown

IF YOU HAVE A **HIT** YOU HAVE AN **EXPERIENCE.** AND IF YOU HAVE AN **AUDIENCE** YOU HAVE A **CAREER.**

1978

On June 26, 1977, after playing Elvis's last show and after his death, I returned to Nashville unemployed. Around the same time, pianist Glen D. Hardin had left Emmylou Harris's The Hot Band to play full time with John Denver. I auditioned for the open slot in Emmylou's band and got the job!

During the years I toured with Emmylou, I made great connections. I was introduced to Rodney Crowell and Vince Gill, and eventually, I would go on tour with ex-members of The Hot Band who became The Cherry Bombs.

Emmylou single-handedly turned me on to West Coast country music, bluegrass, and traditional country. If I went to college, it was at Emmylou Harris University of Music. She was an integral part of my music education. I learned so much from her and am so grateful.

"Tony and I were on the road together in The Hot Band for only a few short years, but what wonderful years those were.
I was so blessed to share the stage with such a gifted musician, but more blessed to know the man, and to have the gift of his friendship; I love you, Tony Brown!"

Emmylou Harris

Emmylou and her mother, Eugenia Harris. Eugenia was Emmy's biggest fan!
On the right, we played A Tennessee Waltz, an event at the State Capitol.

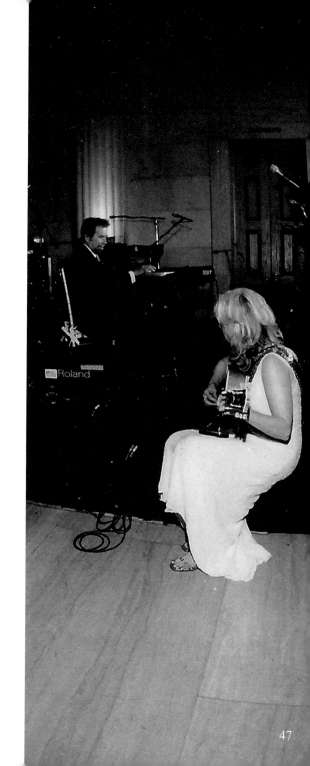

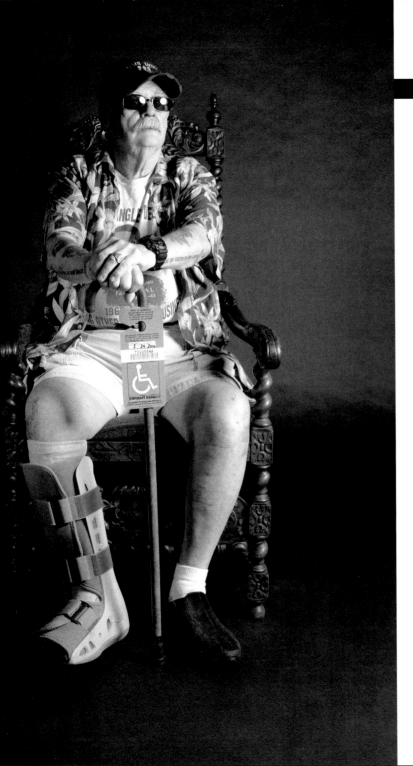

1978

PHIL KAUFMAN

Phil earned his name "The Road Mangler" for his strong temperament while working as Emmylou Harris's road manager.

From the moment I met Phil at LAX Airport—when I arrived to audition for Emmylou's band—I thought he was a most interesting character, and I was right!

After being on the road for a couple of years with him, I learned about his "storied" career. Singer Gram Parsons was the reason the Mangler and Emmylou connected. And after Gram's untimely death, the Mangler would continue as Emmylou's road manager.

It was the Mangler who infamously carried out the burning of Gram Parsons's body, per his wishes, at Joshua Tree. He was also the one who hired the Hell's Angels to be security for the Rolling Stones when they played at Altamont in California.

"Getting in the music business is a swell career move... I highly recommend it for all my enemies." *The Mangler*

A LIGHT (BEER) IN THE STABLE

Away In A Mangler

HAVE A HARLEY NEW YEAR

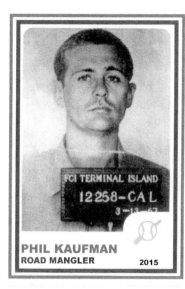

PHIL KAUFMAN
ROAD MANGLER 2015

FCI TERMINAL ISLAND
12258-CAL
3-13-67

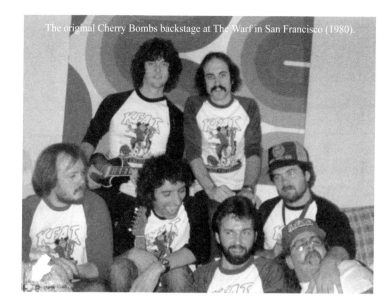

The original Cherry Bombs backstage at The Warf in San Francisco (1980).

THE MANGLER IS SOME KIND OF `CRAZY,` BUT YOU CAN'T HELP **LOVING THE GUY!**

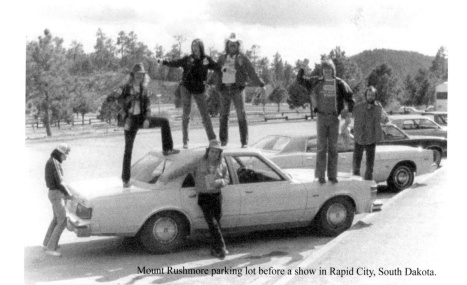

Mount Rushmore parking lot before a show in Rapid City, South Dakota.

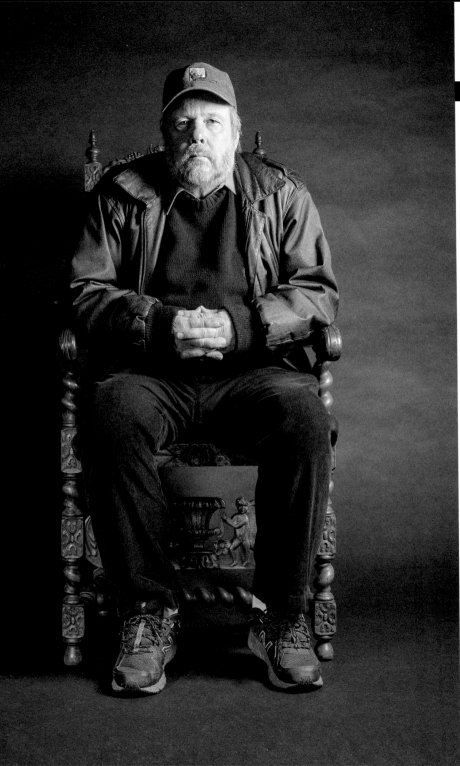

1978

Emory Gordy and I first worked together in The Cherry Bombs. He already had great credibility as a session bass player in Los Angeles, for playing on records with not only Emmylou Harris, but also Billy Joel, Elvis, and many other huge stars.

After signing Patty Loveless to MCA Nashville, I enlisted Emory to co-produce her record because I was still a novice producer at that point. It was one of the best decisions I ever made, for everyone involved. He and I co-produced Patty's first platinum album, *Honky Tonk Angel*, in 1988. And eventually we'd collaborate on three albums with Patty.

After the promotion and marketing department at MCA began to cool their interest in Patty, Emory asked if he could pursue a deal for her at CBS Nashville, who had serious interest in Patty. I guess it was the musician-caring side of me that thought I should agree to let Patty go, and that it would probably be best for her career. And it definitely was!

Emory would go on to produce the best music Patty had ever made on CBS. In hindsight, it may look like a bad decision on my part to lose Patty Loveless to a competitive label. But I looked at it as me helping an artist achieve the success she so deserved. The only way to do that was to sacrifice her, and for her not to be on my MCA roster. I'm happy I let her go because her music will be remembered forever.

"CUN-DA-LOW SHUN-DA-LAY"

Emory Gordy Jr.

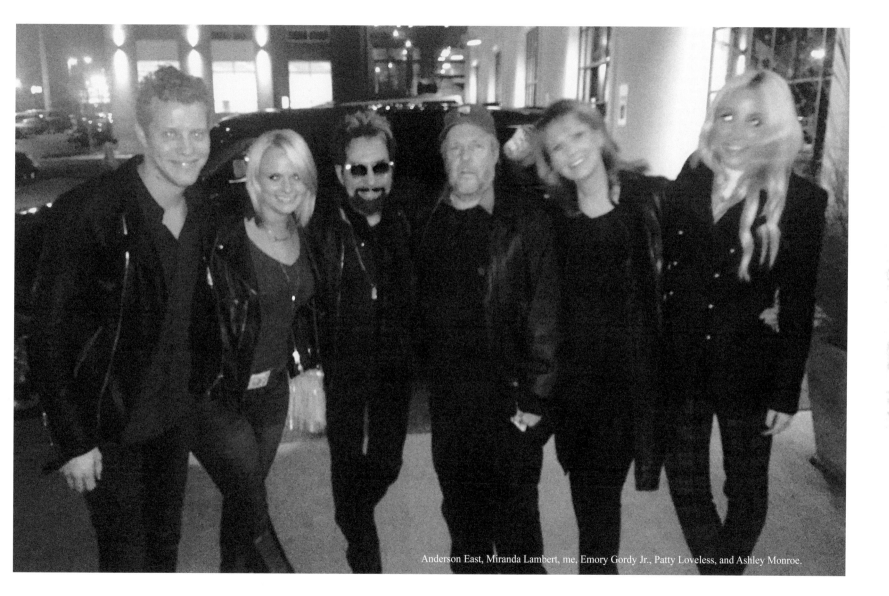

Anderson East, Miranda Lambert, me, Emory Gordy Jr., Patty Loveless, and Ashley Monroe.

EMORY GORDY: A GREAT BASS PLAYER, BUT **THE BEST** COUNTRY MUSIC BASS PLAYER.

TONY BROWN AND THE CHARGING

1978

BABY BUFFALO

YOU WOULDN'T KNOW WHERE OR WHEN YOU WOULD SEE THE BABY BUFFALO COME

Charlie Hodge was a member of the TCB Band; he sang harmonies and was known for handing out scarves during Elvis's shows. I saw Charlie do this thing in Elvis's Las Vegas suite after a show one night, where he would get down on his elbows and knees and crawl around like crazy. Charlie got such a fun response that I stole the move and made it my own gimmick at parties. It later became what I was known for and was requested from people in the studio, at parties, and also at inappropriate times—kind of like Will Ferrell in the movie *Old School* doing the tank. Friends like Ronnie Dunn, Reba McEntire, and Trisha Yearwood started sending me miniature metal buffalo figurines and stuffed buffalo toys from all over the world. Emmylou Harris sent me the one featured on this page. To this day, people still ask me to do it but I retired the BUFFALO on November 9, 2008.

BABY BUFFALO

OUT. I STOLE THE MOVE FROM CHARLIE HODGE, GETTING DOWN ON MY SCRATCHED KNEES AND ELBOWS.

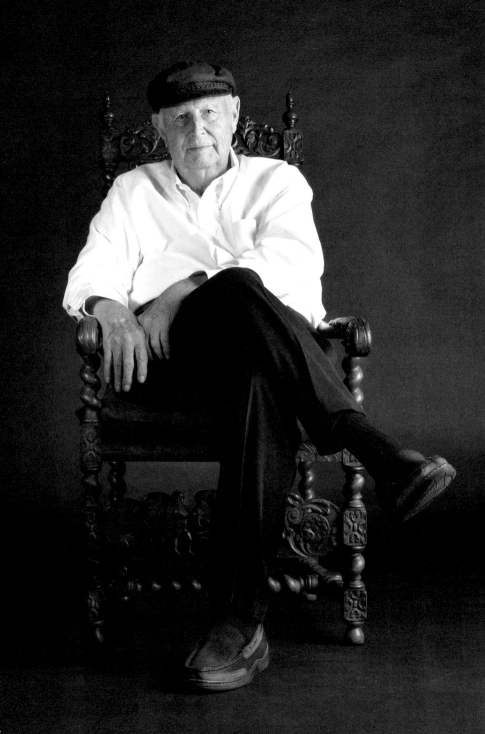

1979

In 1976 something big was happening in Nashville. The label head of RCA Nashville, Jerry Bradley—son of legendary music producer and executive Owen Bradley—had put together a concept album called *Wanted! The Outlaws*. This album featured Willie Nelson, Waylon Jennings, Jessi Colter, and Tompall Glaser. It was the very first platinum album in country music history. It seemed to start a movement of country with an "edge."

Because of the impact of this album, RCA decided to give Jerry his own pop label called Free Flight Records with an office in Los Angeles. Jerry Bradley asked David Briggs to refer someone for the A&R job and Briggs suggested me! Bradley gave me my first A&R job at RCA Free Flight Records, officially making me an executive in the music business. I moved to LA in 1978 at the age of thirty-two. The label closed in 1980, and I worried that I would lose my job. But Jerry's promise to me, as written below, meant that I could breathe a sigh of relief.

Jerry moved me to RCA Nashville's country division, where I remained until 1984. After working there for three years, I signed the band Alabama. It became my first success story as an A&R guy. Jerry was the original country music outlaw, and his vision regarding *Wanted! The Outlaws* changed Nashville forever.

"If you don't make it out there, I'll get you back here before we fire you." *Jerry Bradley*

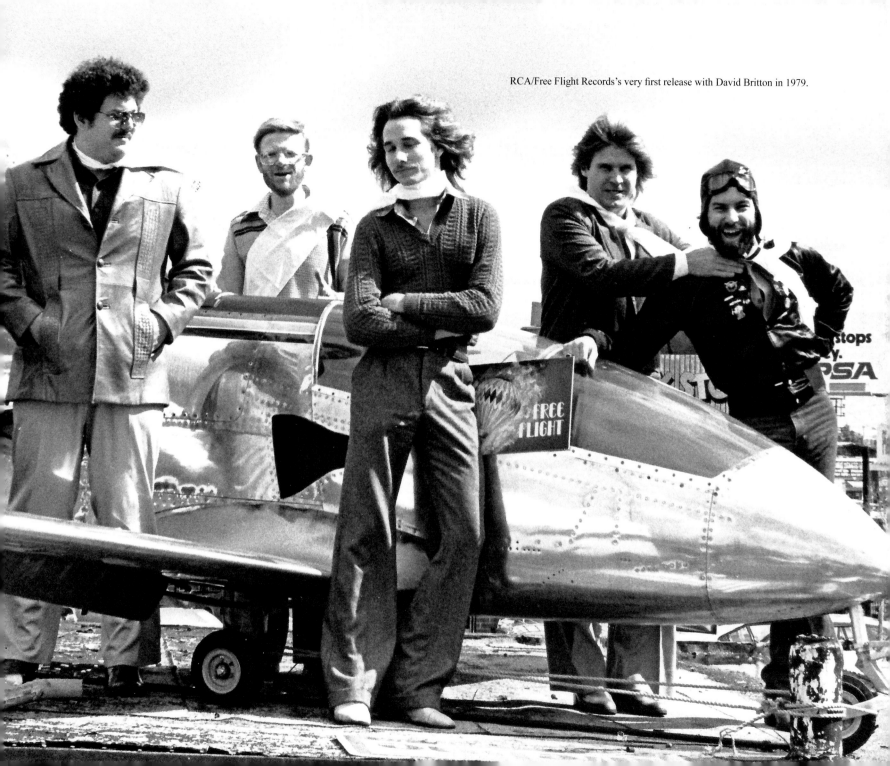

RCA/Free Flight Records's very first release with David Britton in 1979.

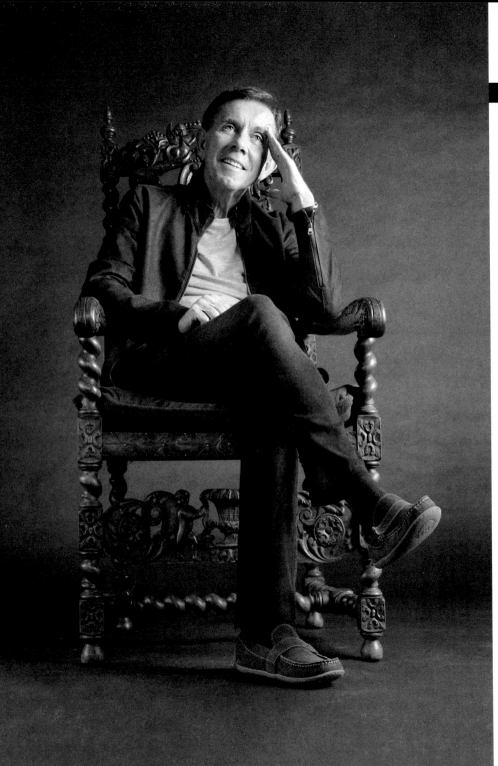

1979

In 1982 Joe Galante, the number two man at RCA Nashville, became head of the label when Jerry Bradley retired and passed the torch. Under Joe's supervision, RCA became a powerhouse. He signed The Judds, and it was Joe who convinced Dolly Parton to do a duet with Kenny Rogers, produced by Barry Gibb, called "Islands in the Stream." This was an epic collaboration.

It was an exciting time for me to be at RCA. Joe let me co-produce my first country hit, *Midnight Fire,* with Norro Wilson for Steve Wariner. He also let me sign Alabama and Vince Gill. As a successful A&R guy at RCA, I thought I'd be there forever, but along came Jimmy Bowen, who stole me away for MCA. Jimmy was trying to disarm Joe but it didn't work. The both of them remained two of the biggest forces in Nashville's country music industry.

"What a great time at RCA. We were there when the next generation of country stars and sounds began." *Joe Galante*

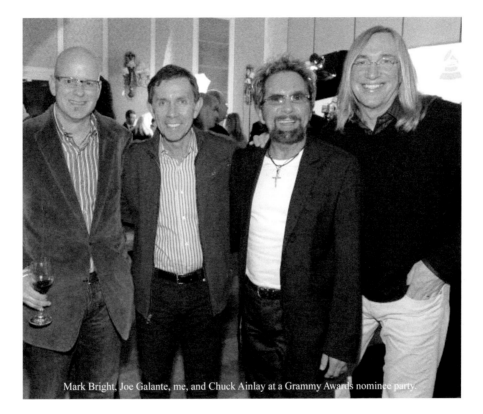

Mark Bright, Joe Galante, me, and Chuck Ainlay at a Grammy Awards nominee party.

JOE GALANTE: **THE POWER BROKER** THAT NASHVILLE NEVER SAW COMING.

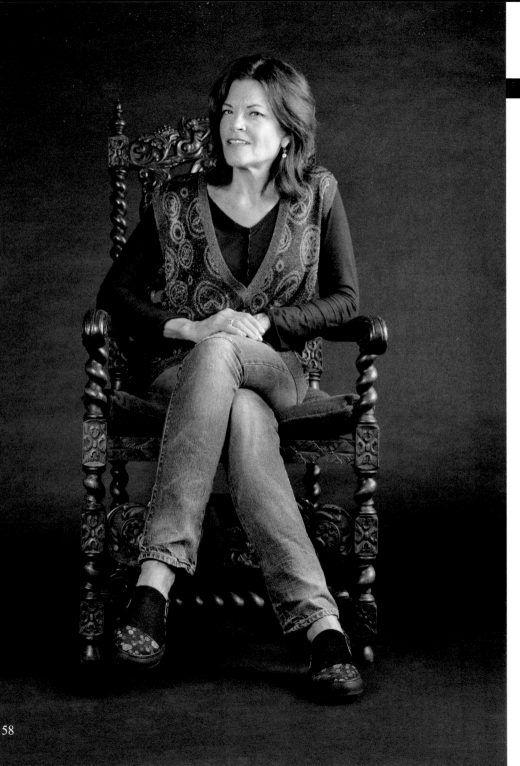

1980

I met Rosanne Cash for the first time in Las Vegas. I was playing keyboards for the Oak Ridge Boys, who were opening the show for Johnny Cash at the Hilton on the Las Vegas Strip. Rosanne was about nineteen years old and was part of the Cash family entourage. I immediately noticed that she was a pretty girl with a very sweet spirit about her. I didn't see her much after that, until I was playing with The Cherry Bombs and she began dating the recently divorced Rodney Crowell. Rodney later produced Rosanne's first record for CBS Nashville, and our band played on the record and also become her touring band—good times!

Rosanne and Rodney got married. And as part of The Cherry Bombs, I played on Rodney's Warner Brothers albums, as well as Rosanne's next two albums, *Right or Wrong* and *Seven Year Ache*, the latter of which included hit songs "Seven Year Ache" and "Blue Moon with Heartache." After I quit playing on the road and became a record executive and producer, I continued to stay in touch with Rosanne and Rodney. By then we were all "chosen family." We all still have a bond, to this day.

Rosanne is currently married to producer and fabulous musician John Leventhal.

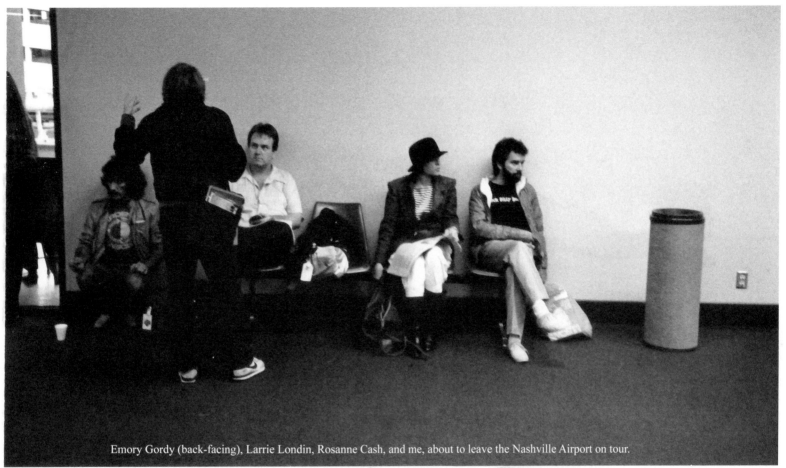

Emory Gordy (back-facing), Larrie Londin, Rosanne Cash, and me, about to leave the Nashville Airport on tour.

for Tony With love Rose

"I've known Tony almost forty years. He has a permanent soft spot in my heart. His generosity as a performer and a friend is unwavering. I still use his one-liners if I want people to think I'm funny. Tony has a place in music history, and in the hearts of those who've worked with him and loved him, that is uniquely his own."

Rosanne Cash

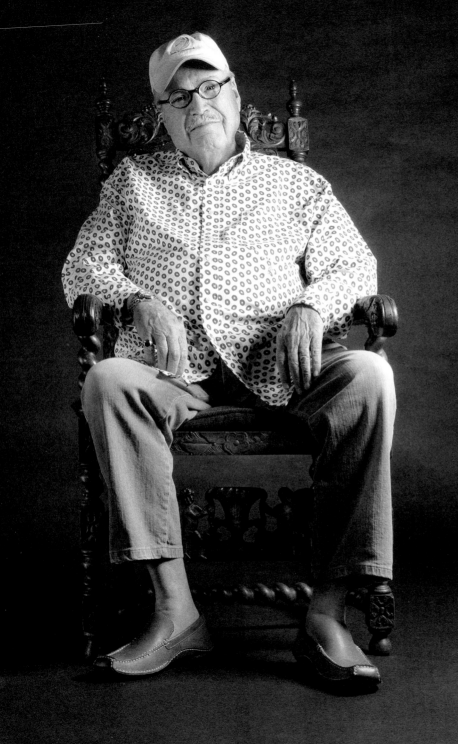

1980
NORRO WILSON

Norro Wilson was always one of the most colorful people on Music Row. He had been an artist himself and had become a successful songwriter and a very successful producer. I really got to know him best in 1980 when I was brought back from Los Angeles to work in RCA Nashville's country division. Norro was the head of the A&R department at that time.

Norro gave me my first shot at producing when he let me co-produce some songs by Steve Wariner in 1983. From this I got my first number one song, "Midnight Fire," on the album *Life's Highway*, and that was the beginning of my career as a producer. I don't even think I got paid for co-producing, but it didn't matter. The opportunity was worth so much more than money!

Norro once signed a publicity shot of him and me with a black Sharpie: *Without me you wouldn't be shit. Norro*. Kind of blunt, but kind of true—thanks, Norro!

Sadly, eight months after the photo on the left was taken, Norro passed away. I was lucky enough to visit him in hospice care just days before he passed. I leaned into him and said, "Hey, Norro, I love ya and I'm not shit again." He whispered back to me, "Don't stop."

I sure wish he could have seen himself in this book, as he was an important person in my life.

RIP (1938–2017)

"Tony Brown wouldn't be shit without me."

Norro Wilson

NOT ONLY A PROLIFIC WRITER BUT **THE FUNNIEST** **SON OF A GUN** MUSIC ROW HAS EVER SEEN.

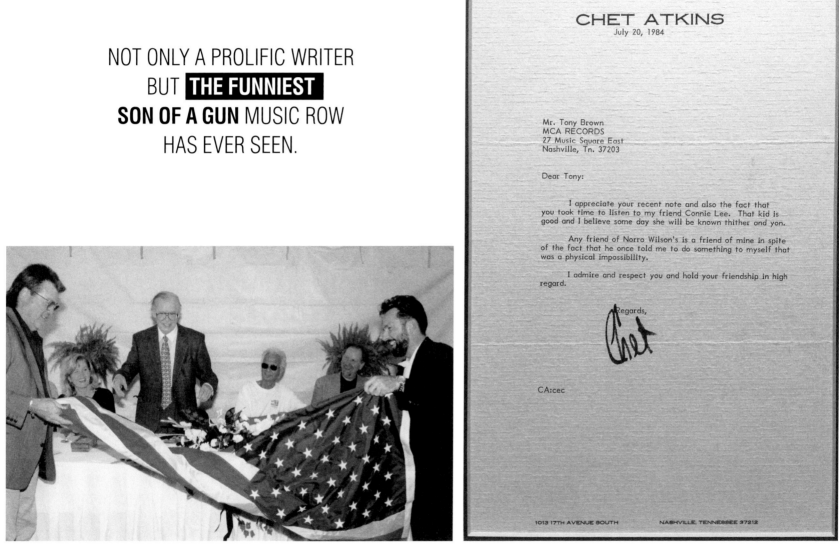

CHET ATKINS

July 20, 1984

Mr. Tony Brown
MCA RECORDS
27 Music Square East
Nashville, Tn. 37203

Dear Tony:

I appreciate your recent note and also the fact that you took time to listen to my friend Connie Lee. That kid is good and I believe some day she will be known thither and yon.

Any friend of Norro Wilson's is a friend of mine in spite of the fact that he once told me to do something to myself that was a physical impossibility.

I admire and respect you and hold your friendship in high regard.

Regards,

Chet

CA:cec

1013 17TH AVENUE SOUTH NASHVILLE, TENNESSEE 37212

The first TV show Elvis ever appeared on was the *Milton Berle Show.* Photo taken at the home of Mae Boren Axton songwriter of "Heartbreak Hotel," (1995).

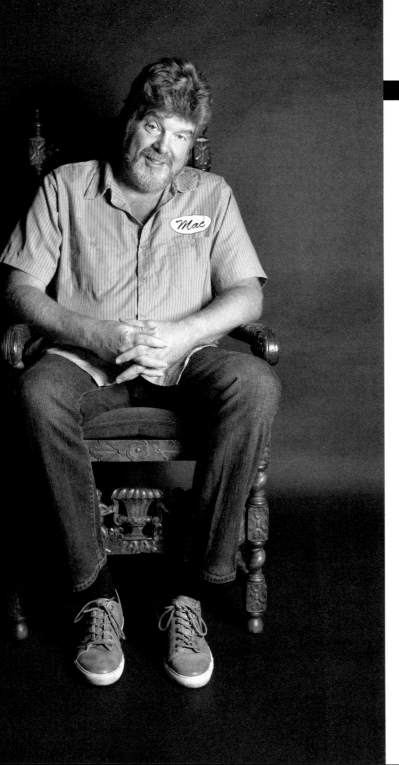

1982

MAC MCANALLY

I first came to know of Mac McAnally when I heard his first hit, "It's a Crazy World," on the radio around 1977. I officially met him soon after at the Exit/In in Nashville. Fast-forward two years and we'd become great friends and remain so to this day.

In 1979 I signed Mac to RCA Free Flight Records. After finishing and turning in his album, Free Flight folded and the album would never be released. I can't believe we're still friends after that experience.

After working with Mac as a session player for many years, in 1992 I signed him to MCA Records and we started to co-produce records.

Mac's *Live and Learn* and *Knots* are two of my favorite albums I ever worked on. I respect Mac as a prolific writer, a great singer, and a fabulous musician. He has won CMA's Musician of the Year Award for eight years in a row. Today he is a big part of Jimmy Buffett's Coral Reefer band. I consider him to be one of the best and most humble people I have ever met in my lifetime.

"It's a crazy world we live in."
Mac McAnally

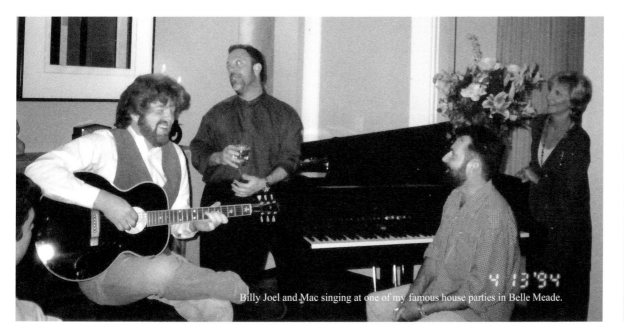
Billy Joel and Mac singing at one of my famous house parties in Belle Meade.

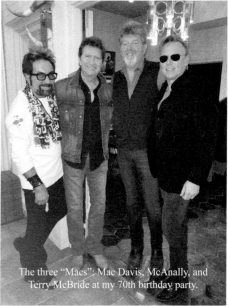
The three "Macs": Mac Davis, McAnally, and Terry McBride at my 70th birthday party.

I'VE GOT MAC ON A **PEDESTAL,** AND I'M KEEPING HIM UP THERE.

THE MUSIC GANGSTER
WHO CHANGED MY LIFE FOREVER

1984
JIMMY BOWEN

FROM FRANK SINATRA TO THE NASHVILLE TAKEOVER, JIMMY BOWEN SHOWED ME HOW TO DO IT HIS WAY!

Jimmy came to Nashville in the late 1970s. He ran Elektra Nashville and eventually would run Warner Brothers Nashville. In March 1984, Irving Azoff tapped him to take the reigns at MCA Nashville with a whole new executive staff, including Bruce Hinton and myself. My life would forever change when I went to work for Jimmy Bowen on March 12, 1984.

Jimmy hired me with the promise of grooming me to be a good record producer. I already knew his history from his days in Los Angeles producing Sinatra, Dean Martin, and other big stars.
In Nashville, he produced the records that would turn Hank Williams Jr. into the biggest act in country music.

He then began the process of making George Strait and Reba McEntire into the icons they are today. He encouraged me to find my own style and artists. From the beginning, he let me co-produce both Jimmy Buffett and Steve Wariner (along with Norro Wilson's blessing). He let me sign Steve Earle, Lyle Lovett, and Nanci Griffith, and also let me start a small jazz label called the Master Series.

Jimmy Bowen made a major impact on Nashville by bringing digital recording to the recording process, putting us ahead of the East and the West Coasts. Bowen is also the reason recording studios would put in Solid State Logic (SSL) mixing boards. He changed the way records were recorded and the way artists were treated in the studio.

Jimmy hands down changed my life and gave me the career that I never would have dreamt of. He is my mentor and my hero, which is why he is the only person photographed in his own chair—maybe we can call it his throne. If the Godfather of Nashville asks you to photograph him sitting in his own chair, you don't say no!

"You take care of the music, and the music will take care of you."

Jimmy Bowen

1984

BRUCE HINTON

In 1984 Bruce Hinton was appointed President of MCA Nashville under Jimmy Bowen as CEO. We were both part of Jimmy's "new regime." When Jimmy left to go to Capitol, Bruce became CEO of MCA and I would rise to the level of president and head of A&R.

Bruce, Scott Borchetta, Walt Wilson, and I were a force to be reckoned with. Together we made MCA the number one country label for ten straight years, earning us the honor of Label of the Decade. Credit not only goes to Bruce and me but to the entire MCA team from the mail room up.

Bruce is a brilliant businessman. Our similar tastes in music made us a great team.

"Being able to work with so many artists whose talent has achieved true greatness is its own very special high and reward."
Bruce Hinton

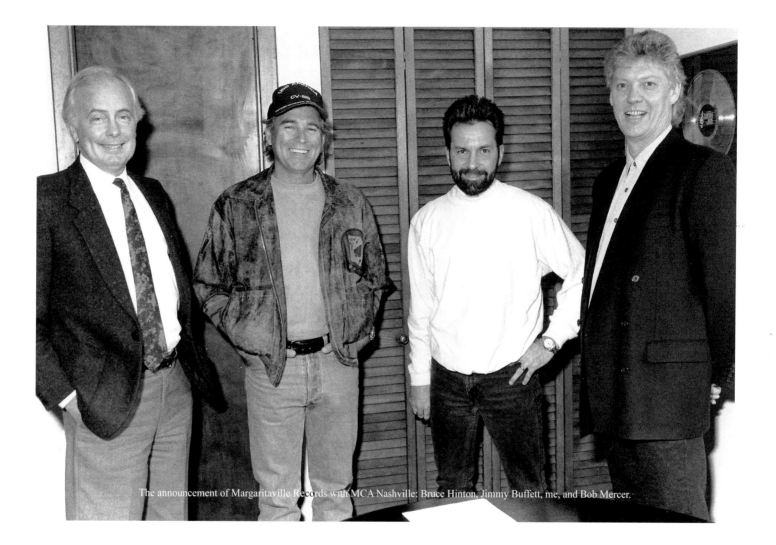

The announcement of Margaritaville Records with MCA Nashville: Bruce Hinton, Jimmy Buffett, me, and Bob Mercer.

AROUND THE OFFICE, **BRUCE WAS** REFERRED TO AS **"THE GOVERNOR"** FOR HIS STATESMAN-LIKE COMPOSURE.

1984

I first heard of Jimmy Buffett back in 1970 when his manager and song publisher at the time, Don Light, wanted to play me some music by a new artist he had found. The first song I heard was "Come Monday" from Jimmy's album *Living and Dying* in ¾ *Time* on ABC Records. His producer eventually became Norbert Putnam, who produced the hit song "Margaritaville." Norbert was a close friend and I pitched songs for his publishing company Danor Music. From that relationship, I ended up getting to hang with Buffett a lot!

In 1984 Jimmy Bowen brought me in as co-producer on Jimmy Buffett's next two albums, *Riddles in the Sand* and *Last Mango in Paris*. During that time, we really did become best buds; I loved his energy and his clever brain.

I learned quickly that Jimmy's brand is much larger than just music. His powerhouse licensing stretches across restaurants, frozen foods, beer, tequila, footwear, and even naming rights to an NFL stadium! Not many artists can claim to have a loyal fan club like Buffett's Parrot Heads. You need to go to a Jimmy Buffett concert to experience the craziness.

It was a good day when I met this amazing creative soul and I'm glad we remain friends to this day! Working with Jimmy sure raised my cool factor!

"Tony Brown, you don't look as old as I know you are."

Jimmy Buffett

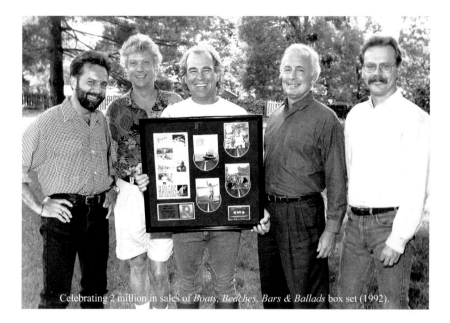

Celebrating 2 million in sales of *Boats, Beaches, Bars & Ballads* box set (1992).

MARGARITAS, HOUSE PARTIES, AND CLOSE CELEBRITY FRIENDS. **BUFFETT** IS THE COOLEST DUDE OF THEM ALL.

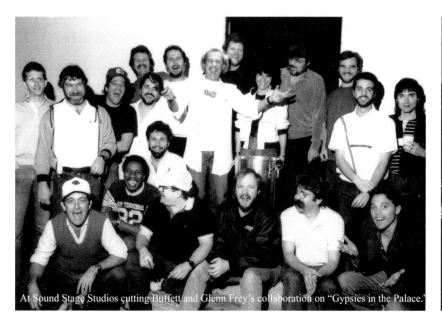

At Sound Stage Studios cutting Buffett and Glenn Frey's collaboration on "Gypsies in the Palace."

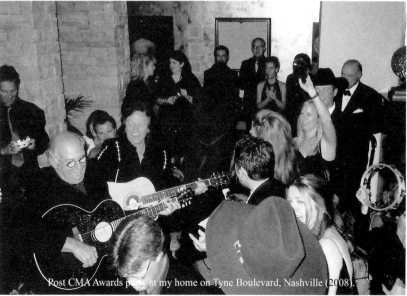

Post CMA Awards party at my home on Tyne Boulevard, Nashville (2008).

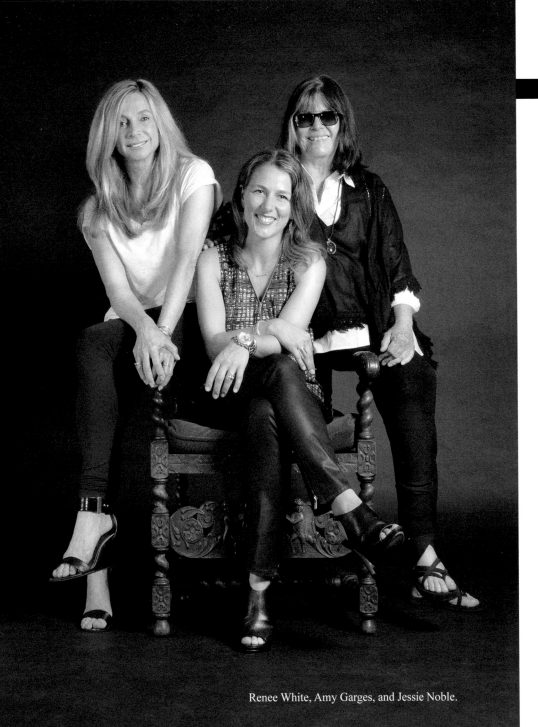

Renee White, Amy Garges, and Jessie Noble.

1984

MY RECORDING TEAM

No A&R executive or record producer could exist without personal assistants and production assistants. Period. My first assistant at MCA Nashville was Renee Bell, who would later become the highest paid A&R person besides me in Nashville.

I couldn't have handled the workload of my job at MCA, later at Universal South, or now as an independent producer if it weren't for my assistants Renee Bell, Renee White, and Jessie Noble in the beginning, and Amy Garges for the last eighteen years. These women have similar qualities: they are all trustworthy, loyal, hardworking, and lovers of country music.

I am so fortunate to have had Amy by my side for all of these years and am lucky to have been able to see her grow into the amazing person that she is today. Everyone who works with me knows that if you're talking to Amy, you're talking to me! I was so fortunate to have the very best Nashville has to offer to support me all through my career.

"Working with Tony all these years has been the ultimate music education. I've never seen someone connect with musicians and artists the way Tony does. It's that relationship that makes his productions timeless." *Amy Garges*

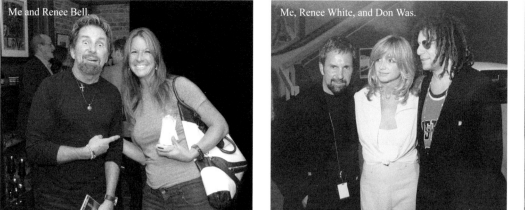

Me and Renee Bell.

Me, Renee White, and Don Was.

Me, Jessie Noble, Renee Bell, Wynonna, Renee White.

NASHVILLE WAS ALWAYS A 'BOYS CLUB' UNTIL THESE WOMEN CAME ALONG!

1. Renee Bell who I worked with from 1984 to 1990.
2. Me with Renee White, who I worked with from 1990 to 2001, and Don Was.
3. Jessie Noble, who worked with me from 1984 to 2001.
4. Amy Garges and me. She has worked with me from 1999 to the present.

Amy Garges, me, and Russell Garges.

Amy Garges and me at my 70th Birthday.

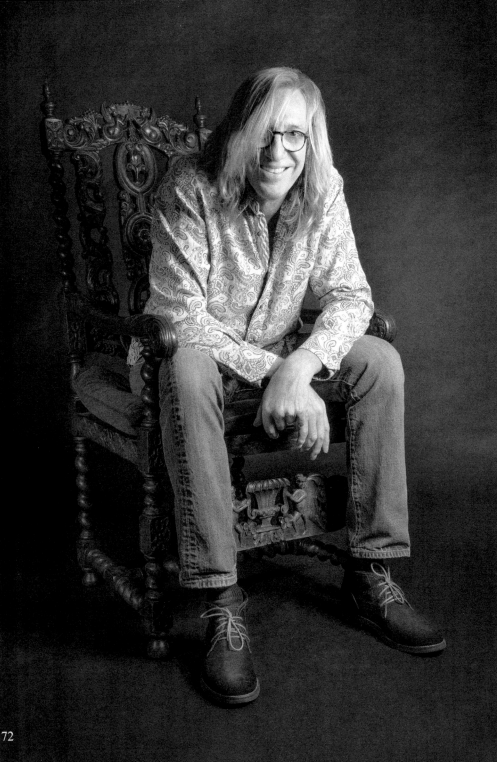

1984

CHUCK AINLAY

I first met Chuck in 1980 when I was a session player doing song demos at Sound Lab Studios, where he was second engineer. In 1984 we started working together and continue to this day.

Some of my most successful records were recorded with Chuck at the soundboard. Together we recorded Wynonna Judd, nineteen George Strait records, Lionel Richie, Trisha Yearwood, Steve Earle, and Lyle Lovett, just to name a few. Our careers really exploded at the same time.

Chuck is not only a master engineer, but also a record producer, who has worked with artists like Miranda Lambert.

Chuck and I have been a strong team and have always remained close friends outside the business as well. Every producer has to have more than one engineer to go to. Along with Chuck, the one other "first call" engineer I'd go to was Steve Marcantonio, a transplant from the Record Plant Studios in New York City. In New York, Steve was working with artist like John Lennon, KISS, Iggy Pop, and other rock stars. Rodney Crowell convinced Steve to move to Nashville in 1992. And Chuck and Steve are the two most successful engineers in town today.

> **"My engineering reputation was built on working with the incredible artists that Tony's productions attracted."**
>
> *Chuck Ainlay*

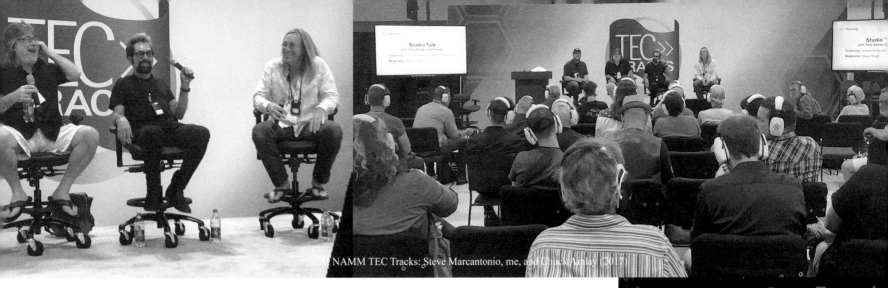

At NAMM TEC Tracks: Steve Marcantonio, me, and Chuck Ainlay (2017)

IS THERE ANYONE BETTER THAN A **WORLD-CLASS ENGINEER FOR A PRODUCER?** NONE MORE BETTER.

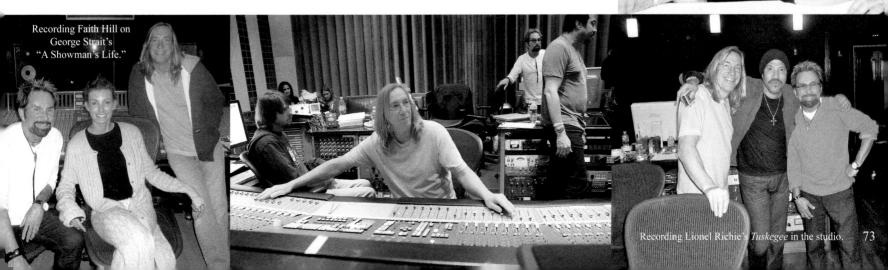

Recording Faith Hill on George Strait's "A Showman's Life."

Recording Lionel Richie's *Tuskegee* in the studio.

1985

PATTY LOVELESS

Patty Loveless was first introduced to me by her brother, Roger Ramey, in 1985. He pretended to have an appointment with me and walked right into my office. I decided to hear him out and he played me demos of his sister, Patty. After hearing a couple of songs and realizing how incredible her voice was, I offered Patty a record deal.

As I mentioned previously, Patty and I did three albums together before we achieved a platinum album, *Honky Tonk Angel*. Even with this success, MCA was still not sold on Patty as a long-term artist. MCA did not pick up her option and let her go, and she signed with CBS Nashville with Emory as her sole producer. She and Emory would also go on to marry.

Patty is no longer with CBS but she continues to record successfully, winning awards and accolades, while associated with other labels. Currently, she is recording independently and touring. Contemporary artists like Miranda Lambert and others look up to her as a true music icon. Patty never compromised her authenticity and has still had a wonderful career—on her own terms. You can't beat that.

Signing Patty was one of the best decisions I ever made as an A&R executive, and in hindsight, although I questioned the decision, letting her go to CBS would free Patty up to achieve the success she so deserved.

"If not for Tony, there would be no Patty Loveless."

Patty Loveless

74

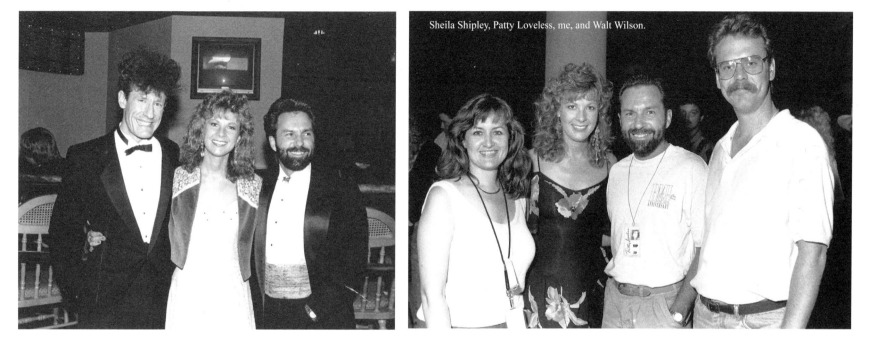

Sheila Shipley, Patty Loveless, me, and Walt Wilson.

THE MODERN HONKY TONK ANGEL.

1985

I first saw Lyle Lovett singing backgrounds with Nanci Griffith on the Nashville network TNN. Nanci was a very respected folk singer-songwriter who I would go on to sign to MCA Nashville. Lyle was a very "high profile" young man in a very nice suit and Lucchese boots with the highest and coolest hair I'd ever seen. When a great songwriter, Guy Clark, heard me asking about Lyle, he gave me a cassette to listen to with some of Lyle's demos. They were so incredible in every way. The songs, the lyrics, and the arrangements were all perfectly presented on this cassette.

I signed Lyle to MCA Curb Records, and after his demos had been heard by every famous producer in Nashville, I was the one who suggested that we should just remix the demos and make them a finished album. He agreed.

Lyle's first album, *Lyle Lovett,* would be a commercial success and a critics' favorite. Using the same way of recording, I produced two more albums with him: *Pontiac* and *Lyle Lovett and His Large Band*, which sold gold and won Lyle a Grammy for Best Male Country Performance in 1990. Lyle continues to play with his Large Band and is still a high-styled Texas gentleman to say the least. He is one of my favorite and dearest friends to this day.

"Tony Brown was willing to take a chance on me in 1985 when he signed me to MCA Records Nashville. I'll always be grateful to him for that." *Lyle Lovett*

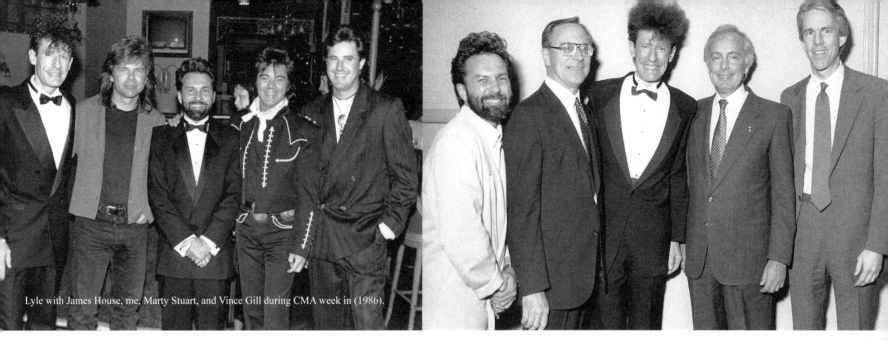

Lyle with James House, me, Marty Stuart, and Vince Gill during CMA week in (1986).

LYLE IS DEFINITELY A QUIRKY ORIGINAL,
FROM HIS HAIR DOWN TO HIS BOOTS.

Robert Earl Keen, Sam Bush, Guy Clark, Lyle, me, and
Jon Randall at the ASCAP Icon Awards.

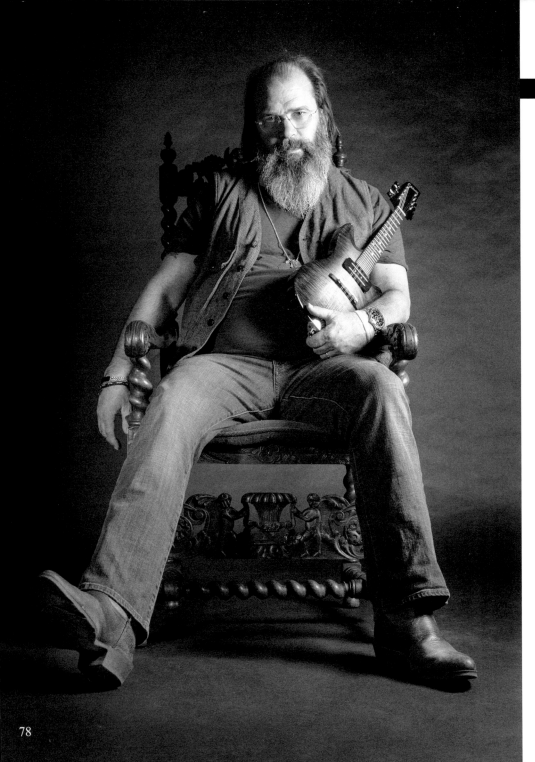

1986

STEVE EARLE

I first noticed Steve Earle when he was on CBS Nashville. At the time, I was A&R at MCA Nashville. He was making retro-sounding rockabilly records. It seemed to me that the label was positioning him to be a "Stray Cats" kind of act.

I got to know him better while we were writers at Silverline Publishing. I went on a writer's retreat to Gulf Shores, Alabama, with Steve and a few other writers, where he proceeded to play me some songs for his next record for CBS. By that time, I knew I was standing with one of the freshest new singer-songwriters I'd heard in years. I told him not to play those songs for CBS because they'd pick up his option and Steve assured me they would hate them! I told Steve that if they hated them, I'd sign him to MCA. CBS dropped him and I signed him. The songs he played me in Gulf Shores became *Guitar Town*.

To this day *Guitar Town* defines my start as a promising producer. In hindsight, it was accidental genius! *Rolling Stone* included it in their May 25, 2012, special collector's issue as one of the 500 greatest albums of all time!

"Jimmy Bowen told Tony he could sign anybody he wanted. Tony said, 'I'm signing Steve Earle.' 'Bowen said, 'Anybody but Steve Earle.' Tony stuck to his guns and here I am today." *Steve Earle*

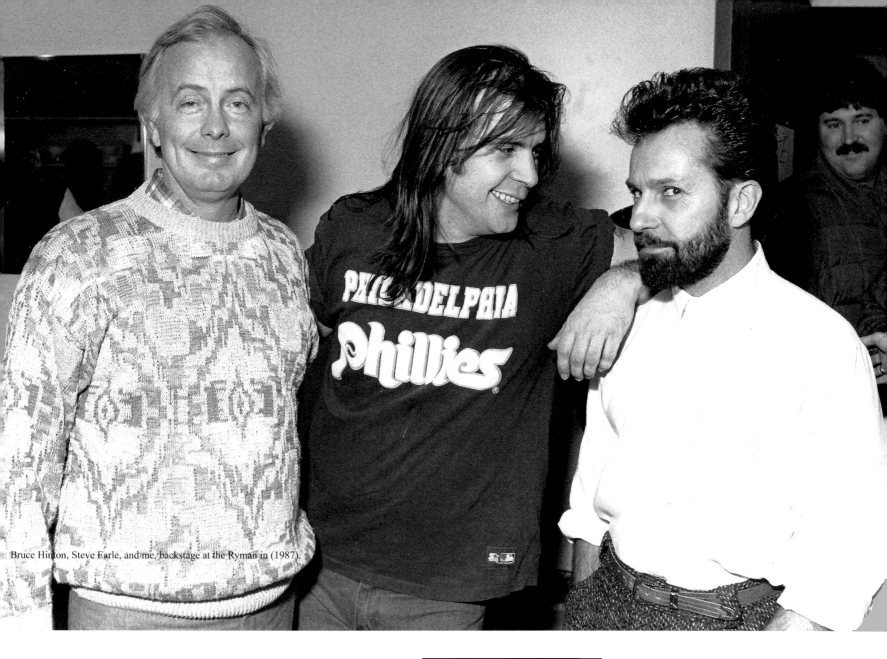

Bruce Hinton, Steve Earle, and me, backstage at the Ryman in (1987).

PART OF THE COUNTRY MUSIC **CREDIBILITY SCARE** OF 1989.

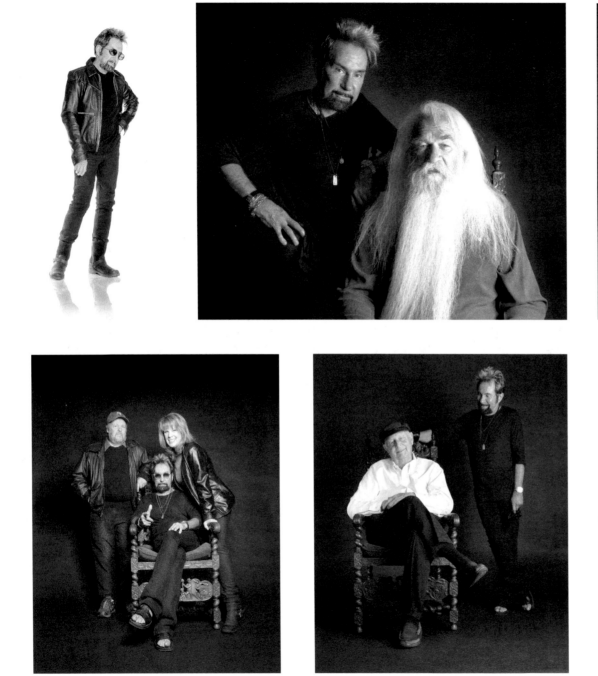

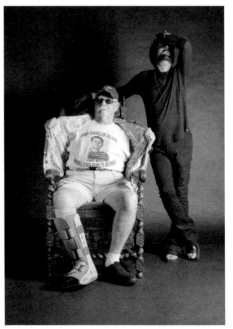

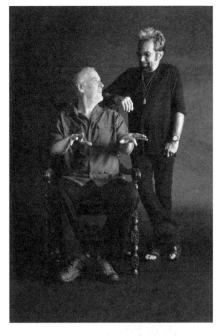
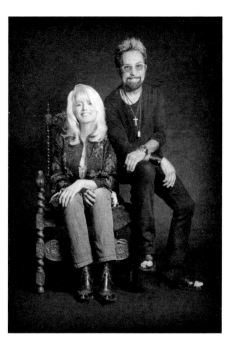
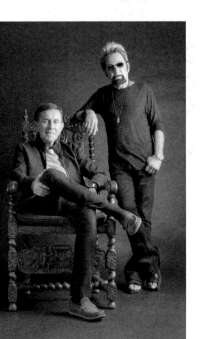
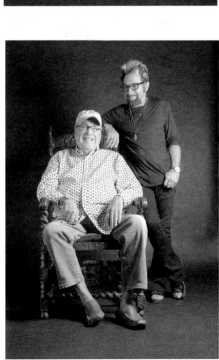
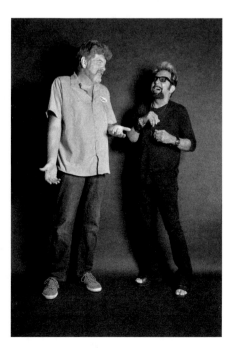

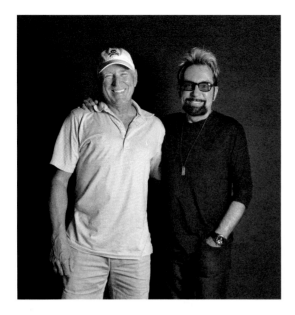

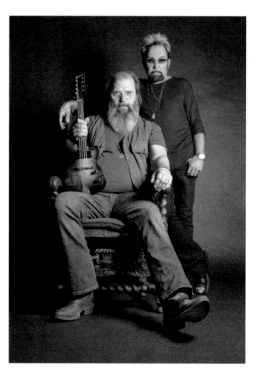

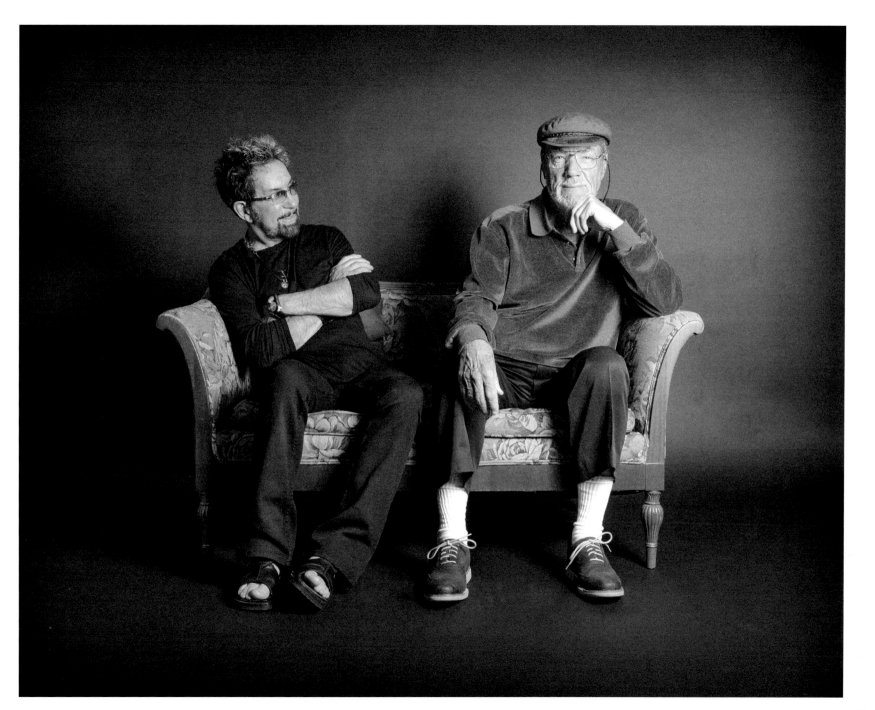

1986

My friendship with Bill Bennett started when he was working in the pop division at CBS Records in New York City. He was originally from Nashville, so he had an affinity for Country Music. Steve Earle had been on CBS Nashville and had not done so well there. When I signed Steve Earle to MCA Nashville, Bill took an interest in what I was doing with him for some reason. It was during this time that Bill would start following what Steve and I were doing in the studio.

After two albums with Steve at MCA Nashville and our third record, *Copperhead Road,* was finished, Jimmy Bowen refused to put it out. By that time, in 1988, Bill Bennett had taken a job with Irving Azoff, with the resurrected UNI Records Label, along with David Simone. Bill agreed to take that record off Jimmy Bowen's hands, and *Copperhead Road* became Steve Earle's biggest album. After UNI Records, Bill helped found Madonna's Maverick label and is now with Fender Guitars as an artist's rep. Bill and I have remained business associates and good friends since that time.

Right: Letter from Jim Dickinson sent to Bill Bennett in realtion to Steve Earle's *Guitar Town* album. To me it was a certifation coming from such a well Respected record producer.

"I have known Tony Brown for most of my life and he has never not been curious about life, art, and music. He introduced me to Steve Earle, Lyle Lovett, Rodney Crowell, and Vince Gill....he is the original Jesus of Cool. Tony is generous in spirit and soul and qualifies on every level as a legend. I am proud to call him my friend."

Bill Bennett

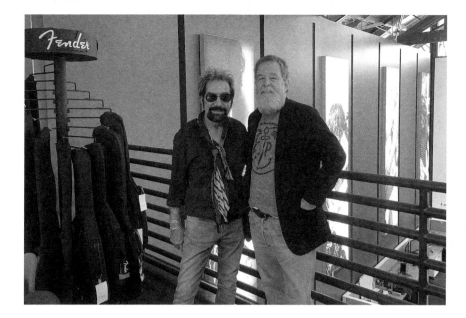

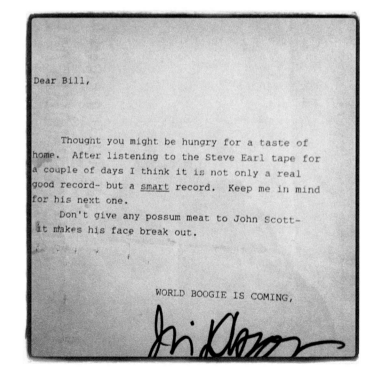

Dear Bill,

Thought you might be hungry for a taste of home. After listening to the Steve Earl tape for a couple of days I think it is not only a real good record- but a <u>smart</u> record. Keep me in mind for his next one.

Don't give any possum meat to John Scott- it makes his face break out.

WORLD BOOGIE IS COMING,

WHEN YOU ASK BILL,
"WHAT DO YOU DO?"
HE ASKS,
"WHAT DO YOU WANT DONE?"

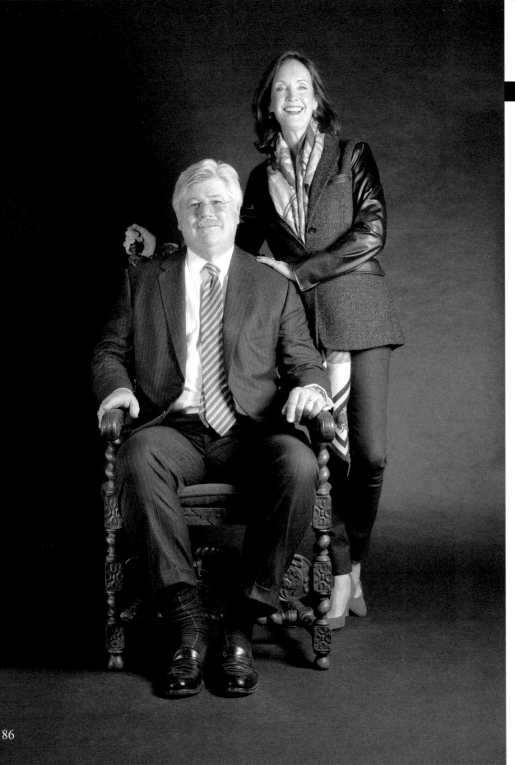

1986

The Nashville music industry is a tight little bubble that few outside of the business have access to. As I was trying to expand my circle of friends, I encountered the president of the Bank of America Nashville, John Stein, and a journalist for the *Nashville Banner* newspaper, Beth Stein. I quickly realized we had similar interests. I learned about Wall Street and they learned about Music Row.

Our paths first crossed nearly thirty years ago when Tony and I were both part of the class of Leadership Nashville, an organization that brings together people from a variety of local interests to learn more about the city and each other. From that, a profound friendship developed that certainly raised the Steins' cool factor exponentially. We have remained close friends all these years, which is a testament to the kind of genuine guy he is."

John Stein

KEEP YOUR FRIENDS CLOSE AND YOUR NEWSPAPER JOURNALIST AND BANKER CLOSER.

1988

I first met Rodney Crowell after joining Emmylou Harris's The Hot Band in 1977. Emmy's husband and producer at the time, Brian Ahern, was producing Rodney's first Warner Brothers album. Emmylou was already doing many of Rodney's songs in her set, so I first came to know him as a songwriter.

I wouldn't get to work with him until Emmylou came off the road to have babies, and The Cherry Bombs were born out of the desire the old Hot Band members had to play. So, we played our first gig at a club in Redondo Beach, California, with Rodney Crowell—thus was the birth of The Cherry Bombs.

The Cherry Bombs was my last gig as a musician. After playing with that band, nothing else would be good enough! Rodney and I both had our first gold record successes when I produced his album *Diamonds & Dirt* in 1988. Rodney still continues to record, write, and just be the iconic singer-songwriter he has become. As a friend, he also became one of my "life advisors." After my brain injury, Rodney helped me recover emotionally and gave me some good advice, which I follow to this day.

"It would take five of everybody else in the music business to equal one of Tony Brown."

Rodney Crowell

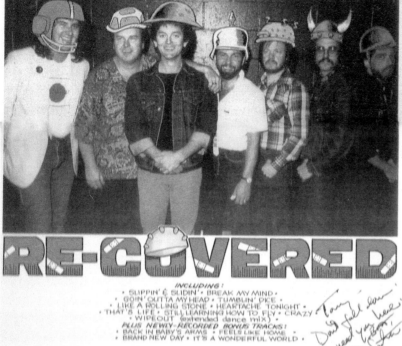

the CHERRY BOMBS

RE-COVERED

INCLUDING:
· SLIPPIN' & SLIDIN' · BREAK MY MIND ·
· GOIN' OUTTA MY HEAD · TUMBLIN' DICE ·
· LIKE A ROLLING STONE · HEARTACHE TONIGHT ·
· THAT'S LIFE · STILL LEARNING HOW TO FLY · CRAZY ·
· WIPEOUT (extended dance mix) ·
PLUS NEWLY-RECORDED BONUS TRACKS!
· BACK IN BABY'S ARMS · FEELS LIKE HOME ·
· BRAND NEW DAY · IT'S A WONDERFUL WORLD ·

My favorite songs written by Rodney Crowell

"Leaving Louisiana" (Recorded by the Oak Ridge Boys)

"Shame on the Moon" (Recorded by Bob Seger)

"Till I Gain Control" (Recorded by Willie Nelson/Emmylou Harris)

"Please Remember Me" (Recorded by Tim McGraw)

"Ain't Living Long Like This" (Recorded by Waylon Jennings)

"Stars on the Water" (Recorded by George Strait)

"Seven Year Ache" (Recorded by Rosanne Cash)

"I Couldn't Leave You If I Tried" (Recorded by Rodney Crowell)

1989

VINCE GILL

I first met Vince Gill when I was playing with The Cherry Bombs. When we had down time, we would play the Los Angeles club circuit for the door.

Albert Lee was our guitar player, but he was also touring with Eric Clapton. So, when Albert couldn't play the club dates, we started rotating the guitar spot to available players. That spot was filled by either Richard Bennett, who toured with Neil Diamond, or Vince Gill, who was the lead singer for Pure Prairie League. Vince ended up being the steady "guitar-slinger" for The Cherry Bombs.

While I was working at RCA, Vince had decided to leave Pure Prairie League and I convinced him to move to Nashville to be a country solo act. He recorded a couple of records for RCA. By then I had moved on to bigger and better things with Bowen at MCA. I brought Vince to MCA in 1989. His first record at MCA was called *When I Call Your Name*. This was the first album I'd produce on Vince, by myself. *When I Call Your Name* launched his career into superstardom as an artist and songwriter!

I went on to produce nine albums on Vince through 2000. Our work together won us two CMA awards and won Vince five Grammy awards.

We are great friends who played in a band together, made records and great memories, and who ended up making ourselves a lot of money, too!

"When you are young and first getting started, you need to find and meet somebody who believes in you and will be a champion for you. Thirty-five years ago, Tony Brown was that for me. And thirty-five years later, he still is."

Vince Gill

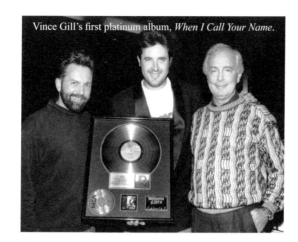
Vince Gill's first platinum album, *When I Call Your Name*.

Vince Gill receiving Hollywood walk of fame star.

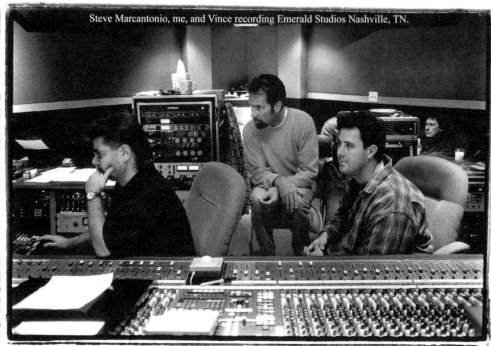
Steve Marcantonio, me, and Vince recording Emerald Studios Nashville, TN.

Tim Whipperman, Bruce Hinton, Vince, Merle Littlefield, Connie Bradley, Tim DuBois, and me.

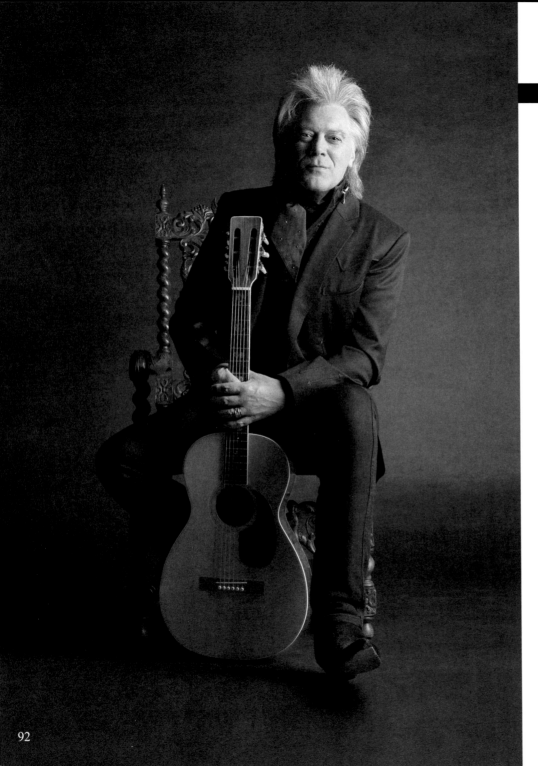

1989

MARTY STUART

Marty Stuart was a bright light in the bluegrass music world, having been playing with Lester Flatt. Even at the age of fifteen he was a striking, high-profile dude with a unique style. On CBS Records Marty tried to blend bluegrass and country for the mainstream, but it didn't seem to work. While I was recording Steve Earle's *Copperhead Road* album at Ardent Studios in Memphis, a dashing Marty Stuart pulled up in his black CJ-7 Jeep, and dressed in black. He said, "I'm not leaving Memphis until you promise to sign me at MCA and produce some hits on me!" I said, "Well, what you got, bro?"

Marty proceeded to play what he called some "beat ballads" that he had written with Paul Kennerley. "Hillbilly Rock" was the first song he played me, and I loved it! It had a Buddy Holly vibe to it and felt fresh for a country record. "Hillbilly Rock" would be the first of many beat ballads Marty and Paul would write. We followed up "Hillbilly Rock" with three more gold albums and a great career was born! Marty is the keeper of the flame for the tradition of country music.

"I saw Tony Brown in person for the first time in 1970. He was playing piano onstage for the Oak Ridge Boys. I thought he was the coolest cat I'd seen. I still think he's the coolest cat I've ever seen."

Marty Stuart

1. Me, Bruce Hinton, Marty Stuart, and Richard Bennett.
2. Me, Marty Stuart with his wife, Connie Smith, and Larry Bud Mellam, CMA after-party.
3. Me, Zack Horowitz, Lou Wasserman, Marty Stuart, Bruce Hinton, Vince Gill, and Al Teller.
4. Nashville's elite session musicians: Lonnie Wilson, Mike Brignardello, John Jorgenson, John Jarvis, Steve Nathan, Paul Franklin, Stuart Duncan, Randy Scruggs, and Belea Fleck with Marty (center right) and me (front right).

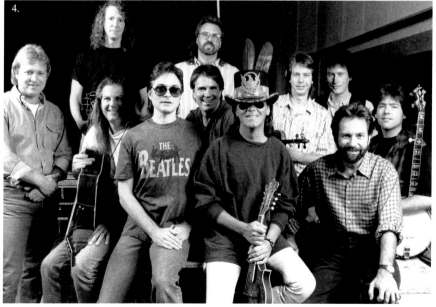

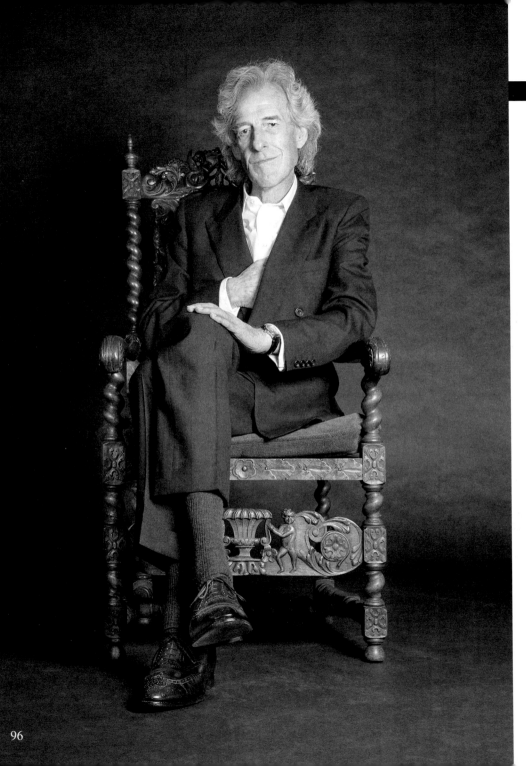

1989

PAUL KENNERLEY

Paul first came to my attention when he married Emmylou Harris. They were both working on Paul's concept album, *White Mansions*, in Los Angeles, featuring Waylon Jennings and Jessi Colter, and Eric Clapton on guitar. Paul had also written hits for The Judds. Paul and I started working together when I signed Marty Stuart in 1989. They wrote the songs called "beat ballads" that would become Marty's signature sound. Three gold albums later, their collaboration would take Marty's career from established artist to superstar status.

When Paul walks into a room, he casts a very refined British sophistication, which cannot go unnoticed. He's a gentle soul and loved by everyone he meets.

"Tony may not be as tall as me but I still look up to him."

Paul Kennerley

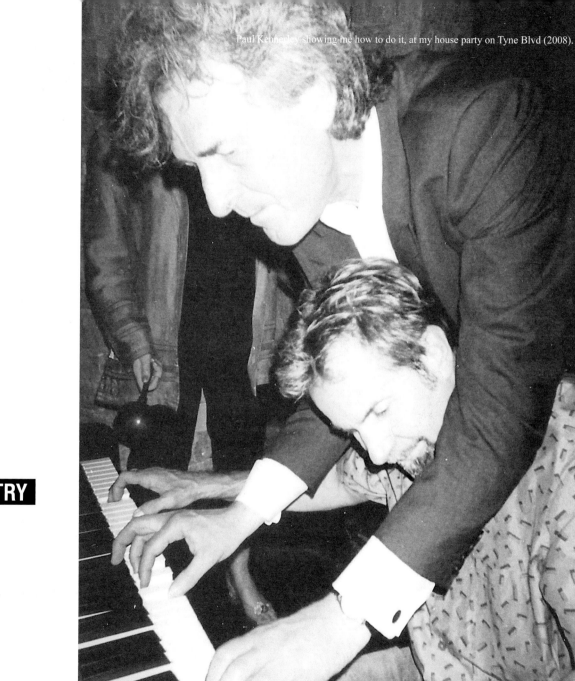

Paul Kennerley showing me how to do it, at my house party on Tyne Blvd (2008).

A BRITISH GENTLEMAN
MORE STEEPED IN
THE TRADITION OF COUNTRY
MUSIC THAN MOST
SOUTHERNERS.

97

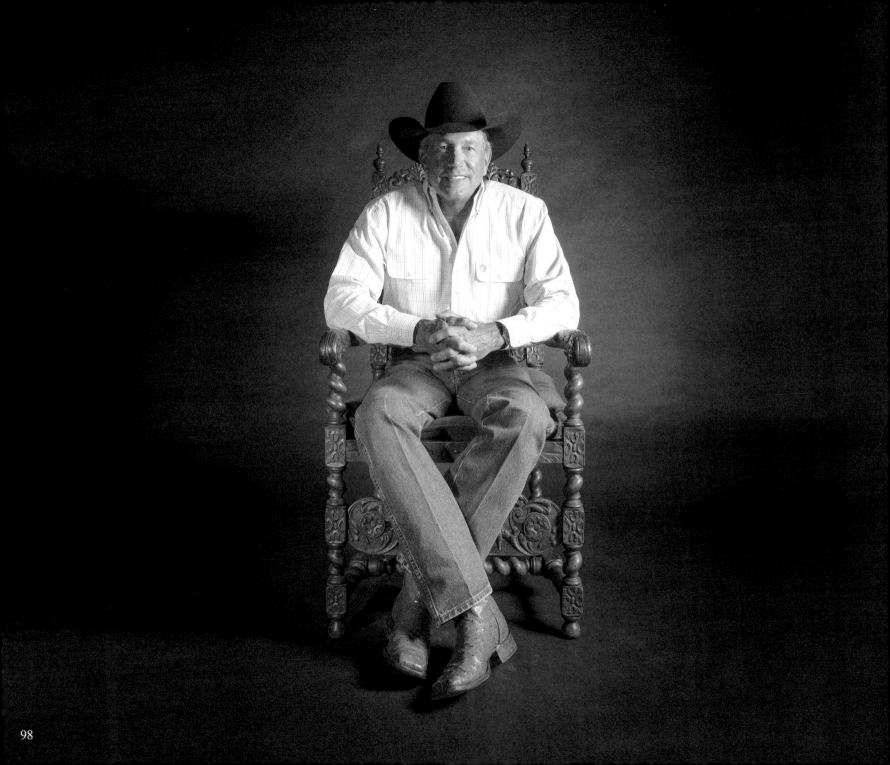

GEORGE **STRAIT** THE `KING` OF COUNTRY MUSIC

OVER 70 MILLION AND COUNTING

OVER 40 ALBUMS AND OVER 60 NUMBER ONE SINGLES

1989

GEORGE STRAIT

I first met George Strait while playing on a Folgers coffee jingle that I'd been hired to do. He was a brand-new artist on MCA Nashville at the time. I was still at RCA Nashville then.

When I came to MCA Nashville in 1984, George was already a superstar being produced by Jimmy Bowen. In 1992, Jimmy left to go to Capitol Nashville, and once again luck would go my way that I would inherit the job of producing my very first George Strait album. That album was *Pure Country* and it also became the biggest-selling album of George's career, going six times platinum.

Of all the artists I have produced, my body of work with George Strait is the best representation of my work as a record producer. The credit goes to George Strait's ability to select great songs and stay true to his roots. He has had sixty number one singles, and thirty-seven of those are from our work together.

I am grateful for having the opportunity to work with such an iconic artist as George Strait. We have been through a lot together over the last twenty years, and I count him as one of my close friends. After all, he is THE King George!

"Tony Brown is going to leave a big footprint in the music world when he decides to step away. I love the fact that he's been such a huge part of my history." *George Strait*

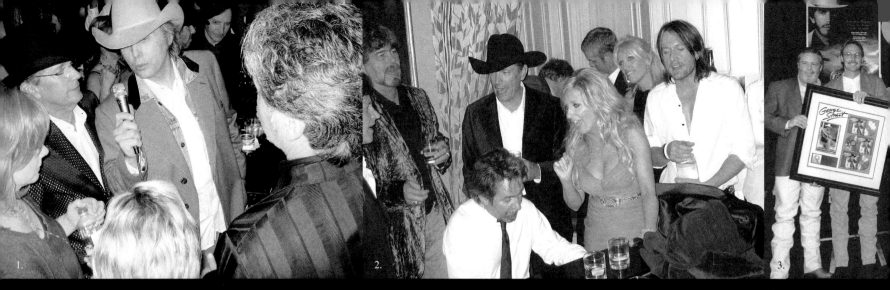

MANY ARTISTS TRY TO REINVENT THEMSELVES TO EXTEND THEIR CAREERS. **GEORGE STRAIT** DID

1. Reba McEntire, George Strait, Dwight Yokam, and Randy Owen at my CMA after-party in (2008).
2. Randy Owen, me, George Strait, Lee Ann Womack, Norma Strait, and Keith Urban at Nancy Jarecki's house party in New York.
3. Royce Risser, Luke Lewis, George Strait, me, and Erv Woolsey at UMG CRS Showcase at the Ryman in Nashville in (2012).
4. Kix Brooks, George Strait, and me at the Nashville launch of George's tequila brand, Codigo 1530.
5. Me, George Strait, and Jamie Foxx at my CMA after-party in (2008).

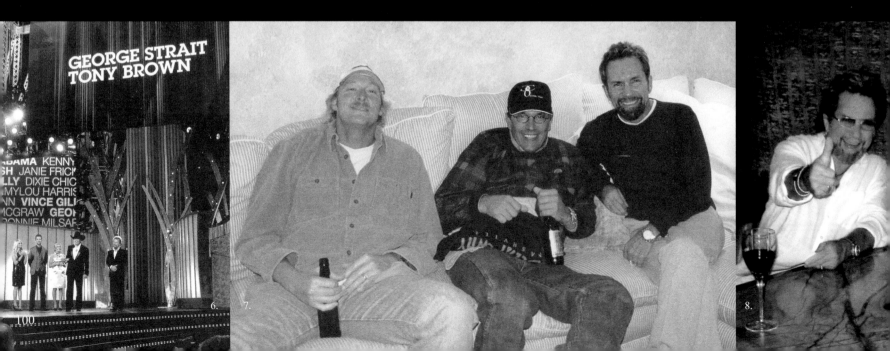

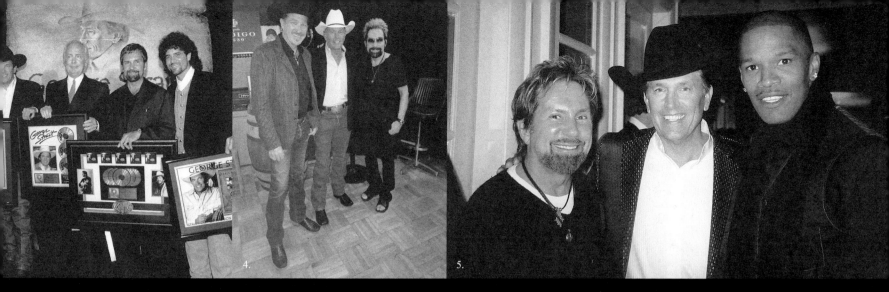

NOT. HE HAS STAYED TRUE TO HIS **TEXAS STYLE** AND THAT'S WHY HE'S **KING OF THE COWBOYS.**

6. Miranda Lambert, Josh Turner, Lee Ann Womack, George Strait, and me at the CMA Awards.
7. Alan Jackson, George Strait, and me recording "Murder on Music Row" at Ocean Way Studios in Nashville.
8. Me and George Strait on his yacht, "Day Money," in Key West, Florida.
9. Chuck Ainlay, Ev Woolsey, and me at the Nashville launch of George Strait's Codigo 1530 tequila.
10. Brian Wright, me, Dean Dillion, George Strait, and Bubba, at Jimmy Buffett's Shrimpboat Recording Studio in Key West.

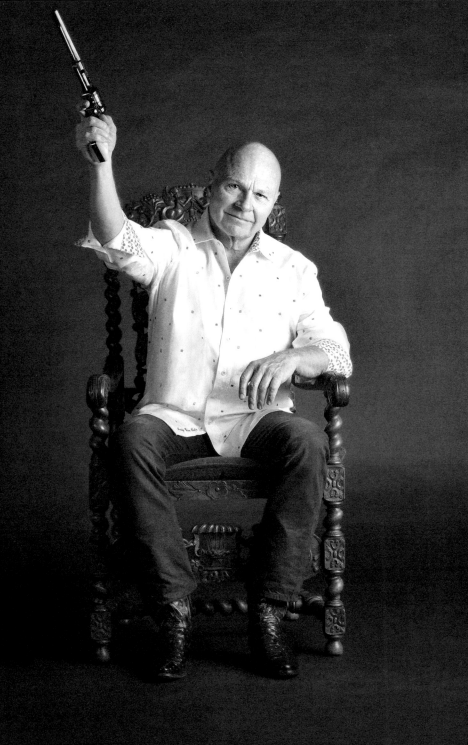

1989

John Mason was always known by everyone as one of the most powerful entertainment attorneys in the business. He was Jimmy Bowen's attorney when I first came to MCA Nashville in 1984. When Jimmy left to go to Capitol Nashville, I was encouraged by Ken Stilts, who managed The Judds, to hire Mason to do my new MCA contract. That was one of the best decisions that I ever made during my career as a record executive. Mason locked me into a very lucrative contract as president of MCA Nashville in 1993, and I remained in that position until I left to start the joint venture with Universal South, with my new partner, Tim Dubois, in 2002. We remain friends to this day.

"I was introduced to Tony by Ken Stilts, who got Tony to open up on how much he was being paid as a high-level executive of a major record company and a superstar producer. When Tony answered, Ken laughed out loud and said, 'You need to hire John Mason.' That was about thirty years ago. We did pretty well!"

John Mason

MCA Records
70 Universal City Plaza
Universal City CA 91608

Tel 818 777 4012

Fax 818 777 8998

Richard Palmese
President

February 1, 1993

Tony Brown
MCA Records
1514 South Street
Nashville, TN 37203

Dear Tony,

Congratulations as you assume the Presidency of MCA Records, Nashville. Although we both hold the title of President, I think you got the better deal.... and you deserve it.

Our continued success is guaranteed because of your talent and dedication.

Warm regards,

Richard Palmese

RP/kf

Tony doodles his perspective of
the musician-producer relationship in
the studio, (1998).

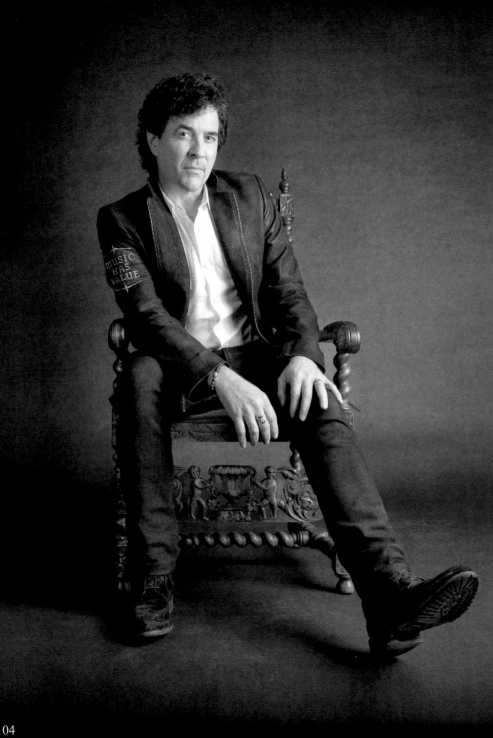

1990

Scott's career ran parallel with mine for years at MCA. He is now one of music's biggest power players, not only in Nashville but in the entire industry. I joined MCA Nashville in March 1984 as vice president of artist and repertoire under the leadership of Jimmy Bowen. Scott was hired to head up the radio promotion department. Only a few years later in 1988, he became vice president and head of the promotion department. He would go on to lead MCA to be Billboard's number one label in Nashville for ten years straight. His license plate said "Dominator," and rightly so.

The combination of my A&R department making great records and Scott's ability to get the music to radio created a force like no other label had in Nashville. MCA became Label of the Decade in the years 1990–2000!

Scott and I were kind of like Don Henley and Glenn Frey of the Eagles. We had our disagreements, but at the end of the day we were both trying to make our statement. I always knew Scott was a game changer. He went on to open his own label, Big Machine Label Group, which is now one of the biggest independent labels of all time. Taylor Swift, his first signing, would become one of the biggest acts to ever come out of Nashville. Period.

"Working with Tony brought out the aggressor in me—my mission was to dominate and we did."

Scott Borchetta

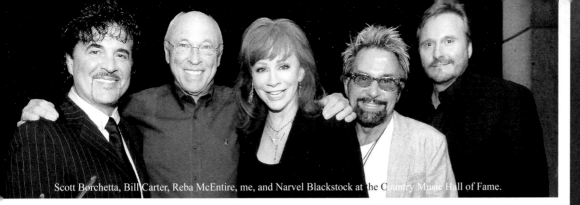

Scott Borchetta, Bill Carter, Reba McEntire, me, and Narvel Blackstock at the Country Music Hall of Fame.

I'M NOT SURPRISED BY SCOTT'S SUCCESS.

HE HAS ACHIEVED SO MUCH AND HE'S A MASSIVE PART OF COUNTRY MUSIC HISTORY.

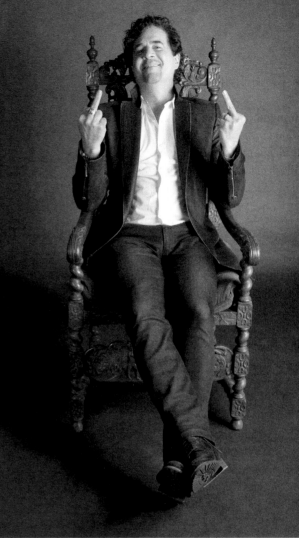

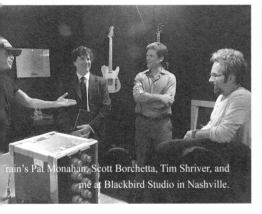

Train's Pat Monahan, Scott Borchetta, Tim Shriver, and me at Blackbird Studio in Nashville.

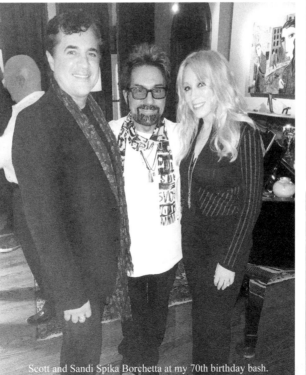

Scott and Sandi Spika Borchetta at my 70th birthday bash.

Me and Scott stand by his Ferrari at my home (2016).

1990

REBA McENTIRE

I first met Reba in 1983 at a concert in San Antonio, Texas, where she opened a show for Charley Pride. I went to the show with Norro Wilson, who I worked with at RCA Nashville in the A&R department. Norro had been hired to produce on Reba's new album *My Kind of Country* on Mercury Records. She was always "bigger than life" to me. Never in a million years would I have dreamed that one day I would get to produce her records. Later, at MCA, Jimmy Bowen broke her into superstardom by producing the hits like "Whoever's in New England" that turned her into a superstar. When Jimmy left MCA to go head up Capitol Nashville, I got the chance to produce her next album, *Rumor Has It*, which garnered the smash hit "Fancy" in 1990.

I would end up doing ten more albums with Reba including her *Reba: Duets* album for MCA. Reba bought me a Harley-Davidson as a gift for producing a platinum album; I later donated it to the Country Music Hall of Fame, which is where it lives now. Reba is always fun to work with in the studio and also remains one of my closest and dearest friends.

I love me some Reba McEntire!

"Tony Brown is one of the most fun people I've ever gotten to work with in the music business. The music we have gotten to record together speaks for itself."

Reba McEntire

Payment from Reba for all the multi-platinum albums we'd been cutting.

My gift from Reba for the album *For My Broken Heart* going platinum.

IT'S NOT ONLY **REBA'S** TALENT THAT MAKES HER **ICONIC.**
IT'S HER **WORK ETHIC, INTEGRITY, AND PERSISTENCE.**
SHE DEVELOPED A POWERHOUSE BRAND THAT IS STILL RELEVANT.

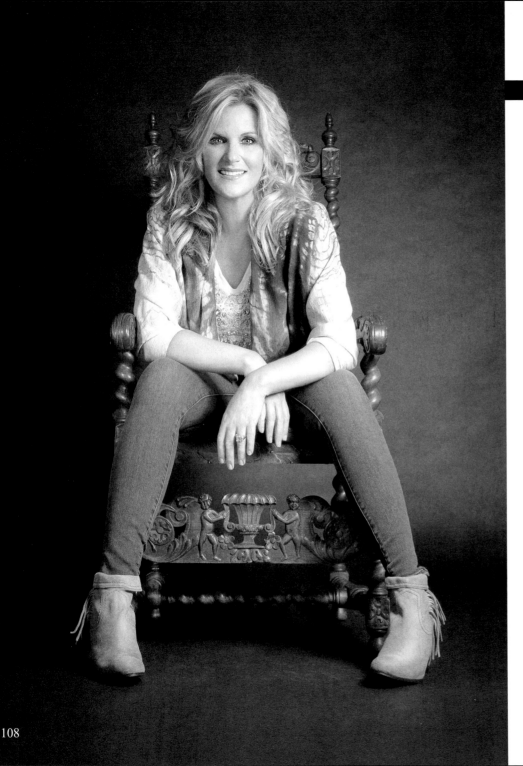

1991

I got to know Trisha Yearwood's voice as she sang on about fifty song demos that publishers would pitch me to cut on artists I was producing. I attended a showcase for Trisha at the Douglas Corner Cafe, a Nashville club used by many to showcase acts they hope to get signed by a label. Trisha blew me away with her presence and that awesome voice. One of the songs she performed that night was "She's in Love with the Boy," which would later become her first number one single on country radio. She would follow that with many, many more smash hits including "How Do I Live," which we recorded for the movie *Con Air* and which won her a Grammy.

She's married to one of country music's greatest icons, Garth Brooks, and still tours with him today, playing to sellout crowds in arenas and stadiums. Trisha is one of the greatest vocalists I have ever worked with.

"When Tony signed me, there were other record labels in the room that night. And he was just like, 'I think what I heard is great and you should go make a record.'"

Trisha Yearwood

HOW COULD I LIVE WITHOUT HER?
TRISHA IS SUCH A BEAUTIFUL SOUL.

1. Ken Kragen, Bruce Hinton, Trisha Yearwood, Garth Fundis, and me celebrating *Hearts in Armor* going platinum.
2. Trisha and me celebrating her number one single "She's in Love with the Boy."
3. Trisha Yearwood, Jon Bon Jovi, and me in Modena, Italy for the Pavarotti and Friends concert in (1998).
4. Trisha, me, and Kathy Nelson after winning a Grammy for "How Do I Live?"
5. Me at Douglas Corner in Nashville, remembering that magic night.

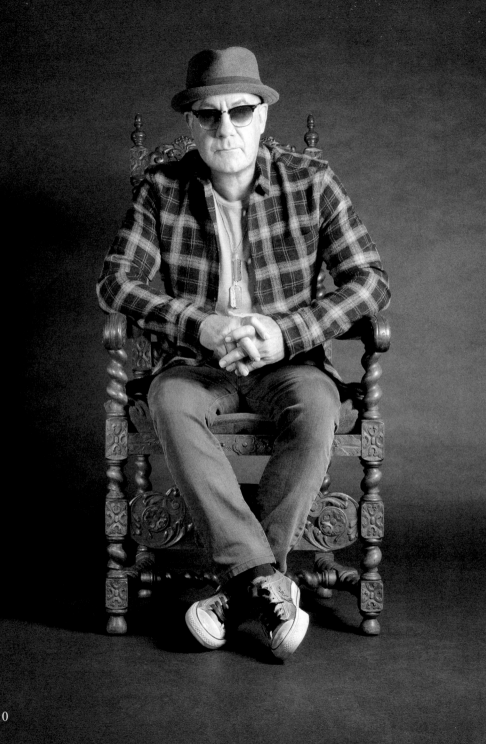

1991

Elton John's album, *Tumbleweed Connection*, introduced me to the pop music that I would most relate to. Everyone has music that influenced them as a musician and made them a music lover. Elton and Bernie Taupin's songs did that for me!

I became friends with Bernie when I was at MCA, during the trips he made to Nashville to become better acquainted with the writers, producers, and musicians here. When I met him, we immediately became good friends. Only because of my friendship with him did I get to meet Elton John backstage in Nashville in 2015. He said he would introduce me to Elton only if I agreed to take him to see Vince Gill and the Time Jumpers the next night. A deal was made!

Bernie sent me the note featured on the next page, after I met him for the first time. It meant a lot to me, which is why I have kept it for all these years.

Happy trails to the Brown Dirt Cowboy!

"When I first came to Nashville, Tony Brown was the king. Since then I've come to realize he's also a prince and a legend."

Bernie Taupin

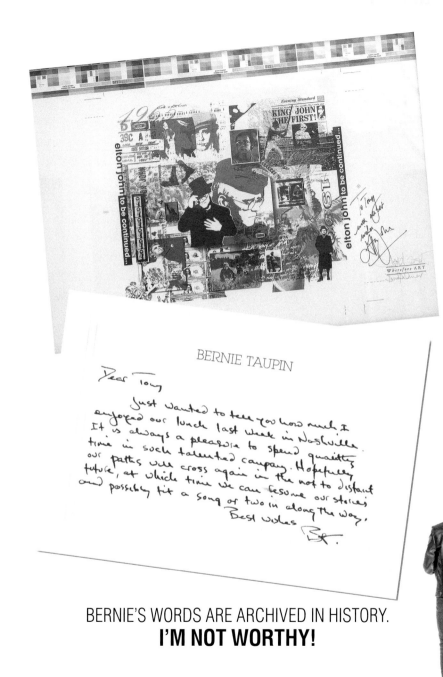

BERNIE TAUPIN

Dear Tony,

Just wanted to tell you how much I enjoyed our lunch last week in Nashville. It is always a pleasure to spend quality time in such talented company. Hopefully our paths will cross again in the not to distant future, at which time we can resume our stories and possibly fit a song or two in along the way.

Best wishes
BT.

BERNIE'S WORDS ARE ARCHIVED IN HISTORY.
I'M NOT WORTHY!

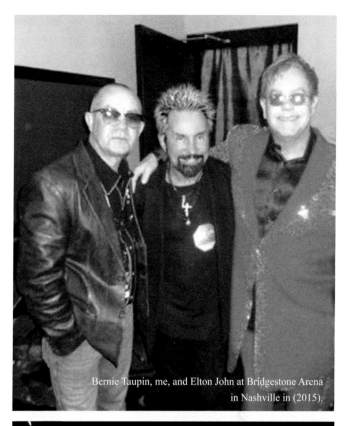

Bernie Taupin, me, and Elton John at Bridgestone Arena
in Nashville in (2015).

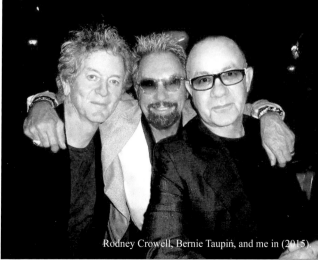

Rodney Crowell, Bernie Taupin, and me in (2015).

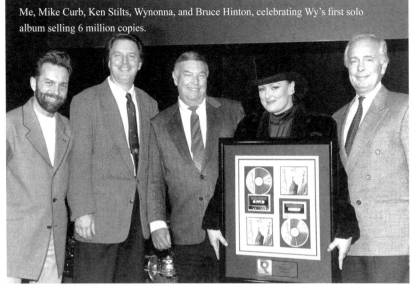

Me, Mike Curb, Ken Stilts, Wynonna, and Bruce Hinton, celebrating Wy's first solo album selling 6 million copies.

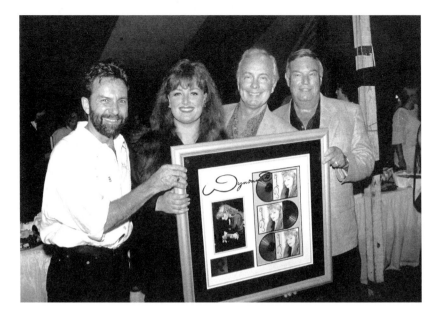

1993

WYNONNA JUDD

I was the director of A&R at RCA Nashville in the early 1980s when RCA president Joe Galante had me come up to his office. He wanted me to hear a mother-daughter duo called The Judds. They sang "John Deere Tractor" and "Mama He's Crazy" in his office with just Wy playing guitar and Naomi singing her harmony. My life was forever changed!

Fast-forward to 1993 and I got the opportunity to produce Wynonna's first solo album since The Judds had retired due to Naomi's illness. What an opportunity—a clean slate to explore what Wy could really do! The first single off her self-titled album, *Wynonna*, was "She Is His Only Need," followed by "No One Else on Earth." Wynonna would sell six times platinum! And I produced two more great albums with her. Wynonna's music is some of the best I've ever been a part of, and I am truly thankful for that.

A FABULOUS CAREER WITH HER MOM IN THE JUDDS AND AS A SOLO ACT.
HER SELF-TITLED FIRST ALBUM SOLD SIX TIMES PLATINUM.

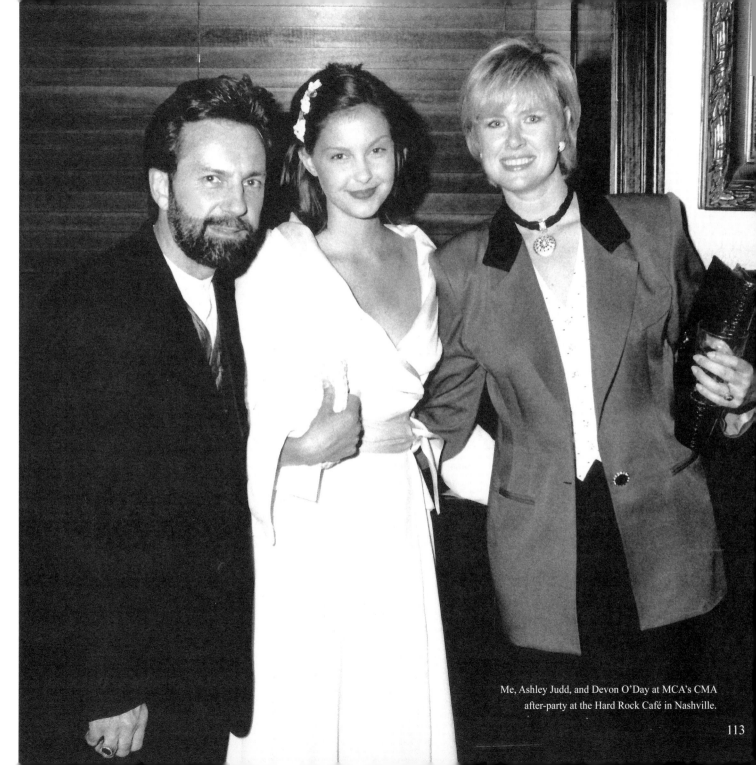

"The baby of the family then, the baby of the family now. I always appreciated being included and being made to feel a part of things. Brother Brown did that the best of anyone."

Ashley Judd

Me, Ashley Judd, and Devon O'Day at MCA's CMA after-party at the Hard Rock Café in Nashville.

113

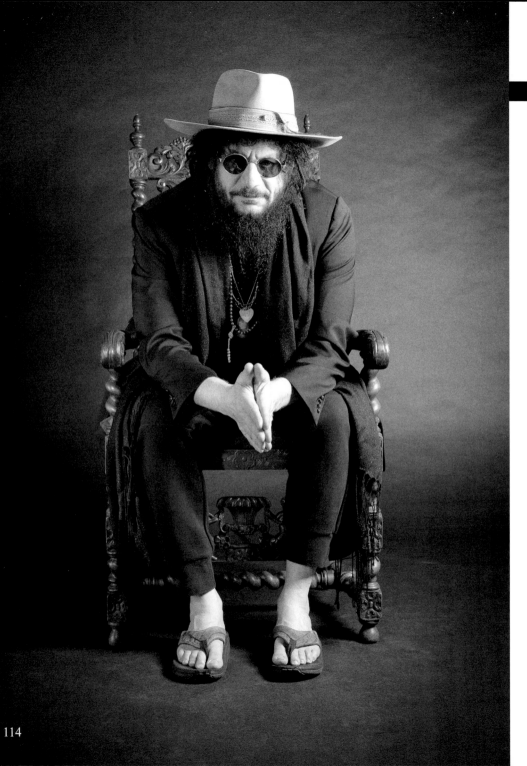

1994

I first became aware of Don Was for his production on two Bonnie Raitt albums, *Luck of the Draw* and *Nick of Time*. These were monster pop albums for Bonnie. I loved Don's production and the fact that he looked like a rock star himself. In fact, he was with his band Was (Not Was). Don was also the producer for one of the biggest bands in the world, the Rolling Stones.

I was asked to help Don when he did a groundbreaking compilation album for MCA. The album was released in 1994 and called *Rhythm, Country & Blues*. It meshed R&B with country, and featured such powerhouse collaborations as Lyle Lovett and Al Green, Reba McEntire and Natalie Cole, Gladys Knight and Vince Gill, and Trisha Yearwood and Aaron Neville. I was honored to just be involved in any way so that I could be around his genius. Our involvement in the *Rhythm, Country & Blues* album also led to our production partnership on Kelly Willis's self-titled album in 1993.

For this book Don flew out to Nashville from California to be photographed in my chair. He "reeks" of coolness and is the only guy I know who could wear flip-flops with a tuxedo, which I recall he did when he attended the Tennessee Waltz event at the State Capitol.

"Don Was is the epitome of cool."

Tony Brown

Me, Trisha Yearwood, Aaron Neville, and Don Was recording *Rhythm, Country & Blues* in New Orleans.

"In addition to being one of the giants of record making, Tony's also been a dear friend for over thirty years. He generously unlocked the gates to Nashville and showed me how to make records there, which is something I am eternally grateful for. We've shared some wild times—VERY wild—times and have had some unforgettable studio adventures."

Don Was

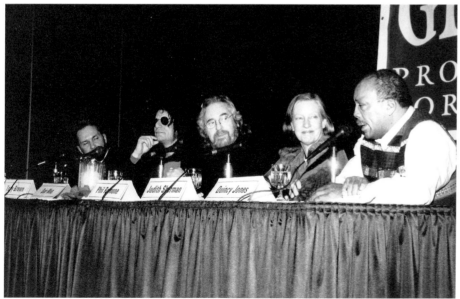

Me, Don Was, Phil Ramone, Judith Sherman, and Quincy Jones at the NAMM Grammy forum in Los Angeles.

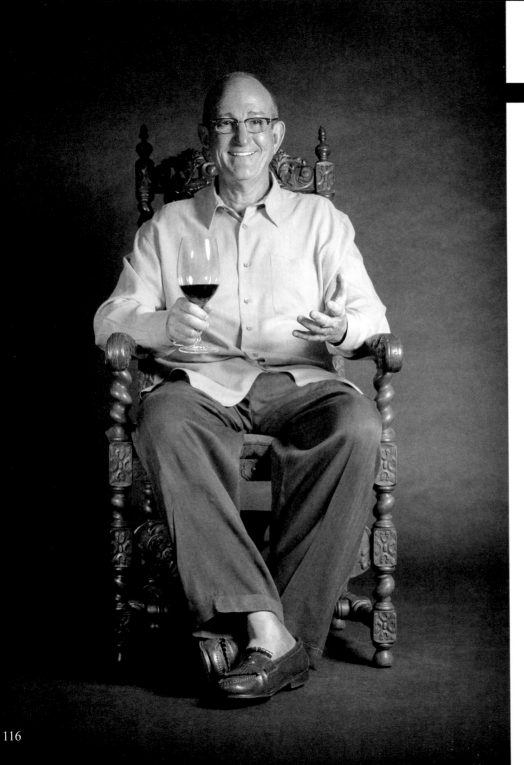

1995

I met Tom Black around 1999, as he was the center of a social group that I called "wine snobs."

He loved hanging around music people and I loved drinking his wine. Tom has the biggest and best wine collection in all of Nashville, and maybe even the whole country. He is renowned worldwide for his expertise of fine wine.

I think it was Tom who, when he heard about my accident in Los Angeles on April 11, 2003, immediately called Dr. Paul McCombs, who jumped on a plane and flew to LA. To my fortune, he's another one of the angels who were on call that night!

Thank you, Tom, for your friendship!

TOM BLACK IS A **WINE SNOB!**

"For over thirty years Tony has made me laugh. He is entertainment personified. A truly great man."

Tom Black

THAT IS NOT A DIS, IT'S A COMPLIMENT.

117

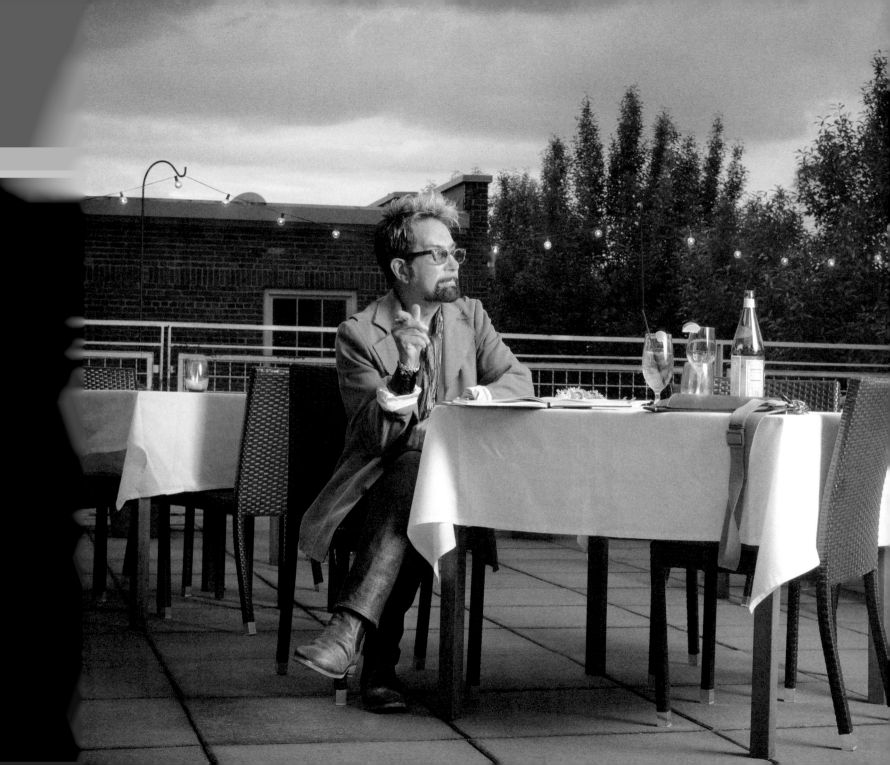

WATERMARK

RESTAURANT

EST. 2005

BESIDES MUSIC, MY OTHER GREAT LOVES INCLUDE FOOD, FASHION, AND FAST CARS.

I've celebrated my biggest deals and accomplishments over dinner; I love great food and having it in a restaurant with a cool vibe, which is so important. Just like a good vibe in a recording studio, it makes the whole experience of sharing a meal better. I have great memories of recording with Reba in the studio then going out to dine and relax at the Watermark.

Tony Brown

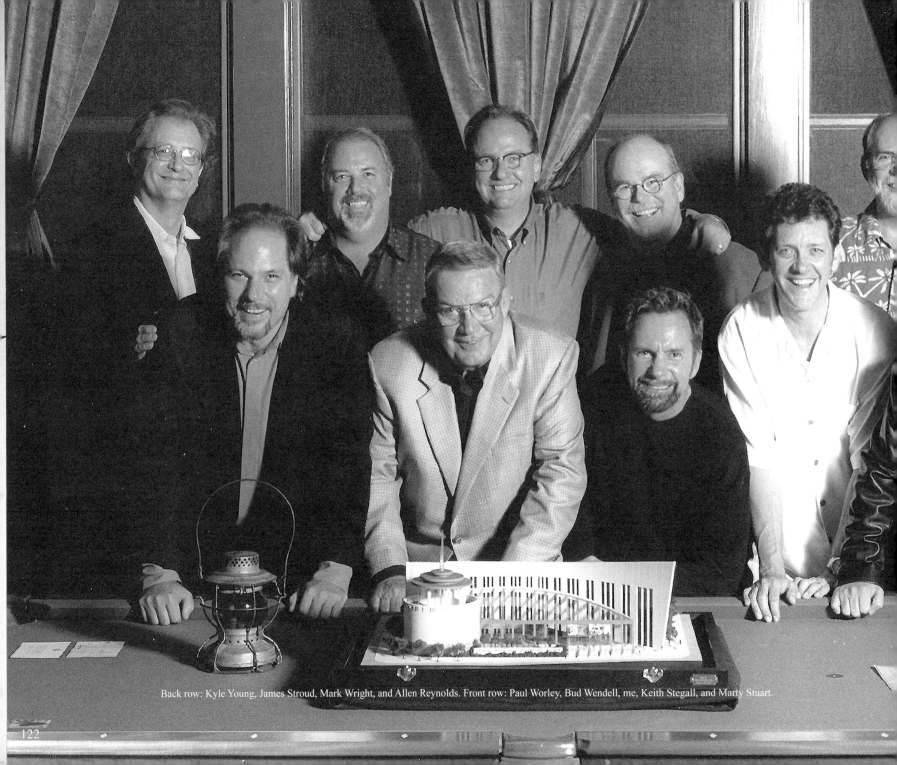

Back row: Kyle Young, James Stroud, Mark Wright, and Allen Reynolds. Front row: Paul Worley, Bud Wendell, me, Keith Stegall, and Marty Stuart.

2001

DINNER PARTY AT TONY BROWN'S HOUSE: $25,000 A HEAD

In 2000, the Country Music Hall of Fame launched a fund-raising campaign to pay for a new, more expansive building for fans. A design had been approved by its board, and now it was time to raise money to build it.

I had a bright idea to challenge all the top record producers in Nashville, who were raking in a lot of money working with major artists, and who probably would eventually be in the Hall of Fame, to get involved in the fund-raising campaign. We all had a vested interest in preserving the country music legacy.

Kyle Young and Bud Wendell joined me in hosting the dinner, with the catch being that everyone was invited, as long as they each brought a $25,000 check with them to donate to the building fund. After dinner, we all retired to my pool table room, where I proceeded to lay down my check for $25,000, and everyone else followed. That night we raised over $200,000 for the Hall of Fame! I am proud of my involvement with the Country Music Hall of Fame in its fund-raising, as well as serving on the board.

OVER $200,000 AND FRIENDS POOLING TOGETHER COUNTRY MEMORABILIA KICK-STARTED THE GREAT NEW HALL OF FAME BUILDING.

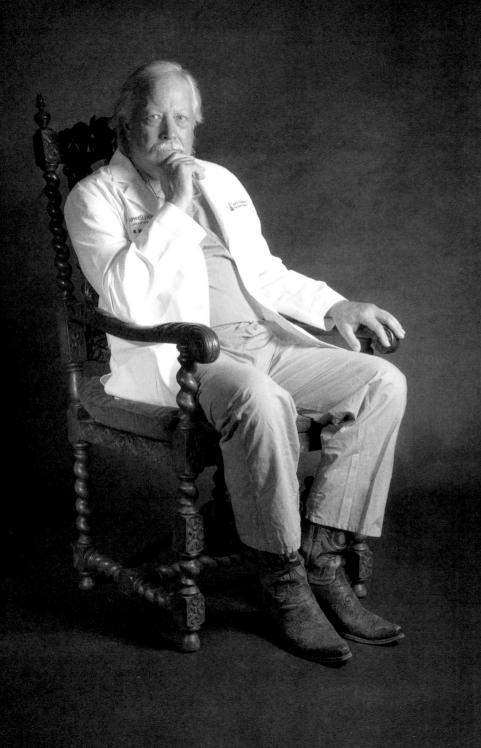

2003

PAUL McCOMBS

Dr. Paul McCombs literally saved my life in April 2003, after I had a devastating fall at a business dinner in Los Angeles. I suffered a traumatic brain injury when I fell down a flight of stairs. I was rushed to the UCLA Trauma Center due to the severity of my head injury. Dr. Paul received a phone call regarding my accident and rushed out to see if he could help.

It's a long story, but Paul's immediate response changed the course of my life. Before this, Paul and I had become friends through a social group of wine snobs in Nashville. This group included Tom Black, among others. Dr. Paul is proof to me that angels do exist! That's the only explanation I have as to what occurred when he arrived at the UCLA Trauma Center that night.

A near-death experience shifted my perception on mortality and made me start thinking about my priorities. As time passed, I found out that the reason I fell was because I had been drunk. So on November 9, 2008, I stopped drinking alcohol completely.

People say I'm a different person post-brain trauma and I agree—I am, but for the better. I am more serious and I don't take my friends or success for granted, like I used to. I still consider myself funny but in more of a calculated way; after all, I'm still the "Charging Baby Buffalo!" Life is good!

I am forever indebted to Dr. Paul. He and his wife, Carla, are, needless to say, two of my closest friends.

"For it is in giving, we receive."
Saint Francis of Assisi

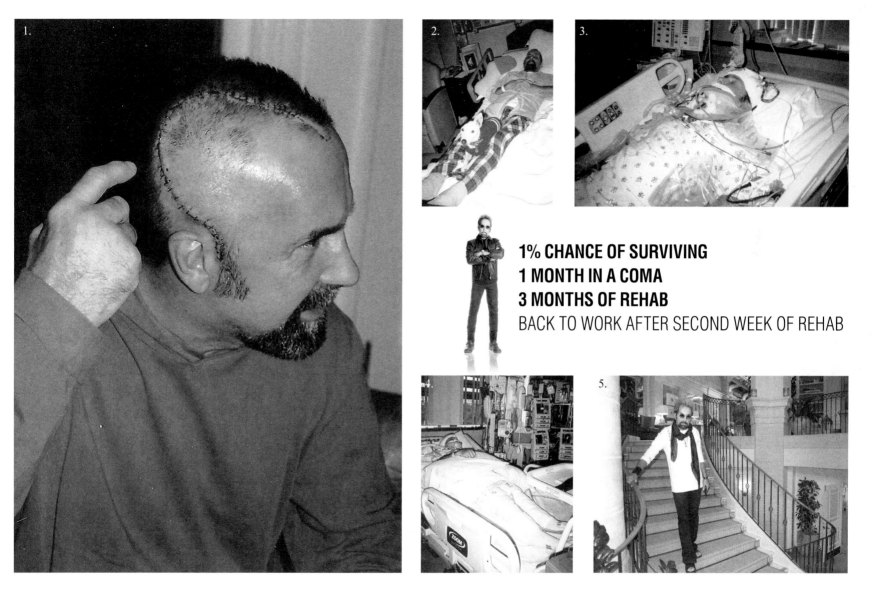

1% CHANCE OF SURVIVING
1 MONTH IN A COMA
3 MONTHS OF REHAB
BACK TO WORK AFTER SECOND WEEK OF REHAB

Brain trauma left me stranded in Los Angeles, as I was unable to travel on a commercial airline due to air pressure and my need for hospital medical assistance. My insurance didn't cover an ambulance jet, which would've cost a fortune. Luckily, Reba McEntire immediately insisted she fly me home to Nashville in her private jet at her expense. She's not just a friend, she's an ANGEL.

1. Recovering in Nashville after Dr. Paul McCombs put my skull cap back in.
2.3.4. Photos taken by my then wife, Anastasia Brown, while I was in a coma at the UCLA Trauma Center.
5. Me in 2017, revisiting the steps that almost took my life at Casa Del Mar in Santa Monica, California.

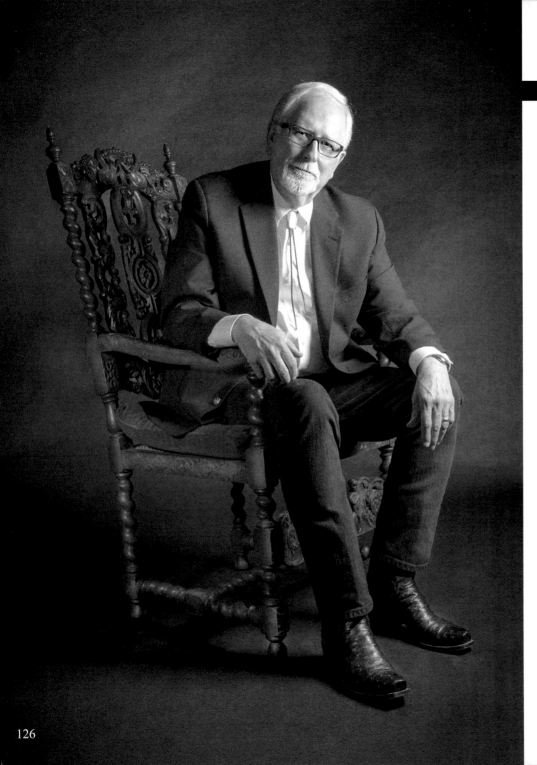

2003

Tim Dubois was first an accountant who became a successful songwriter and eventually opened Arista Nashville under Clive Davis. He's responsible for the careers of Alan Jackson, Brooks & Dunn, and a host of other artists.

Our careers first intersected when he co-wrote "When I Call Your Name" for Vince Gill. That song exploded Vince's career as an artist and mine as a producer. Years later, Tim and I ended up working together as co-owners of the joint venture with Universal Music Group, Universal South Records.

Twenty years before that, we were Music Row's main competitors as heads of the two most successful labels for many years: MCA and Arista Nashville. We both had similar musical tastes and had enough success at those labels to think we should join forces. I'm glad we did, and to this day we call each other "partner."

"It was a dream come true to become partners with the man who produced some of my favorite music in the whole world."

Tim DuBois

The Universal South Team celebrating the gold album status of Pat Green's *Wave on Wave*.

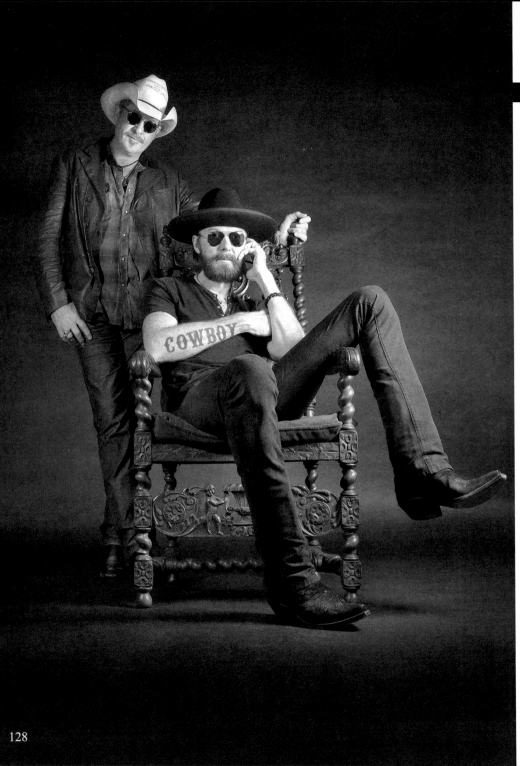

2005

BROOKS & DUNN

I was at MCA Nashville when Brooks & Dunn came out with their first single, "Brand New Man." I knew immediately that they were going to be huge! I was running Universal South with Tim DuBois when B&D asked me to produce my first album with them, *Hillbilly Deluxe*, which went platinum.

From that album, we helped them to win their first CMA Single of the Year with "Believe" in 2006.

Following that success, I produced one more album with them, *Cowboy Town*, in 2007. Ronnie and Kix are two of my favorite artists that I've worked with and remain good pals!

"Tony was the 'cat' that I moved to Nashville to work with. He gravitated to artist types that were most often unique and cutting edge, but at the same time he was very much a purist and traditionalist. He didn't try to dictate to the people that he worked with how to do what they did; he challenged them to be all that they could be. He sought, as he does today, authenticity not compliance."

Ronnie Dunn

Recording Brooks & Dunn's song "Building Bridges," featuring Vince Gill and Sheryl Crow. It won the ACM Vocal Event of the Year award in 2006.

HILLBILLY DELUXE IS THE PERFECT DESCRIPTION OF **BROOKS & DUNN.**

Me, Ronnie Dunn, Terry McBride, and Jim Sohr at the Daytona 500. Coors was Brooks & Dunn's tour sponsor.

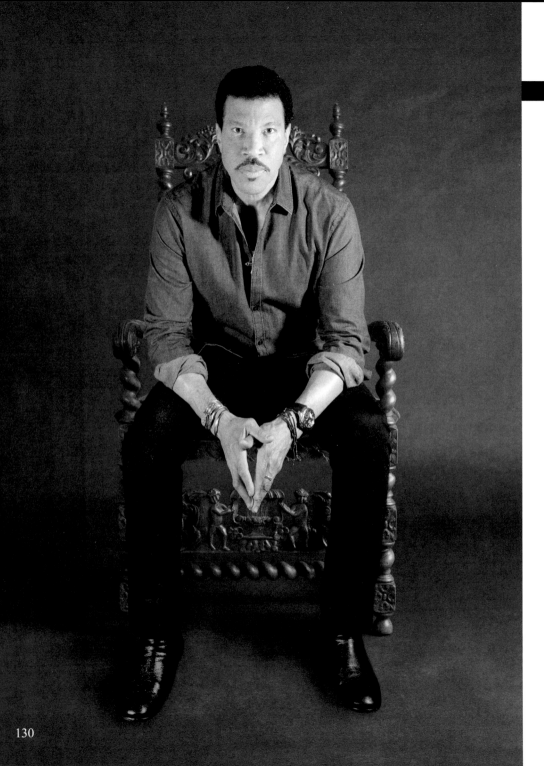

2012

Lionel Richie and I met briefly around 2009. In 2012, he asked me to produce an album with him that would include duets with various country artists performing some of his biggest hits from the '70s. That album would be called *Tuskegee*.

Lionel and I immediately developed a strong connection, and recording with him became a fun and successful experience. The album sold 3 million copies worldwide, became the biggest album he had released in years, and the second biggest selling album of 2012. Working with Lionel on that project has been a highlight in my career and one of the best albums I have ever been a part of as a producer.

"It ain't EASY being EASY, but Tony's sense of humor makes it EASY."

Lionel Richie

RECREATING **WORLD RENOWED HITS** WAS HARD, BUT IT ENDED UP BEING ONE OF **MY BIGGEST ACCOMPLISMENTS** AND ONE OF **THE BEST RECORDS** I'VE EVER WORKED ON.

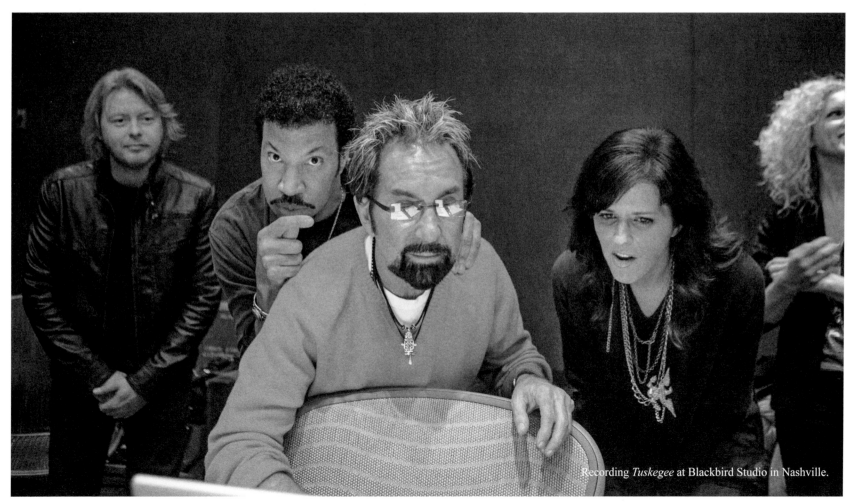

Recording *Tuskegee* at Blackbird Studio in Nashville.

No one ever asked me for my side of the story…
In this case, I was guilty until proven innocent.

On September 27, 2017, the State of Tennessee dismissed the domestic assault charges against me.
Being cautioned never to speak about this was frustrating and hurtful. Being innocent didn't seem to matter,
but in the end my faith in God prevailed and is what got me through it.

"I was blind, but now I see."

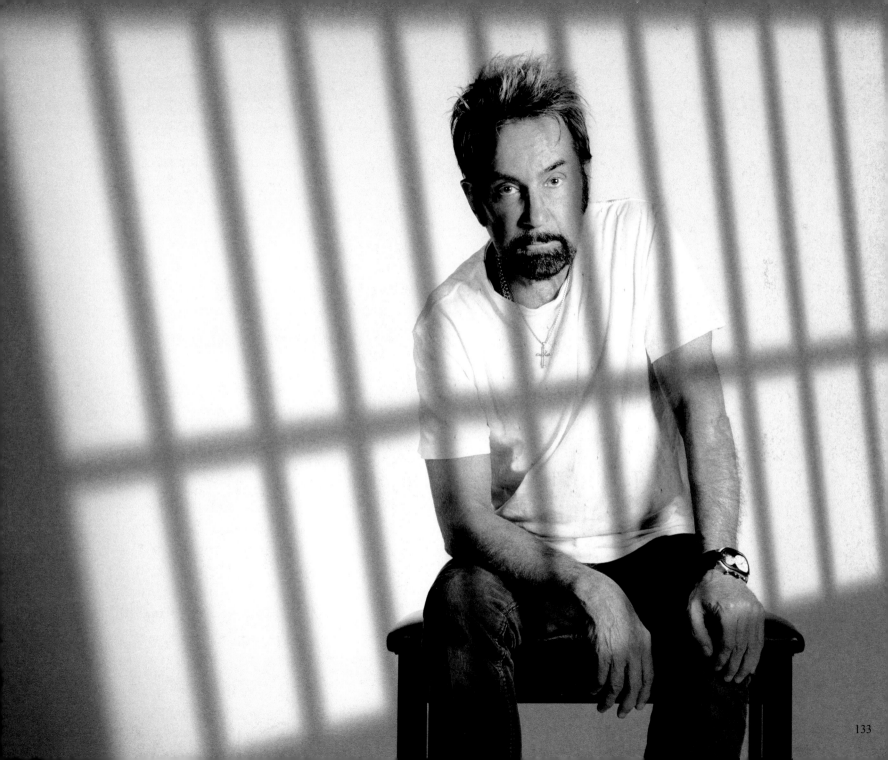

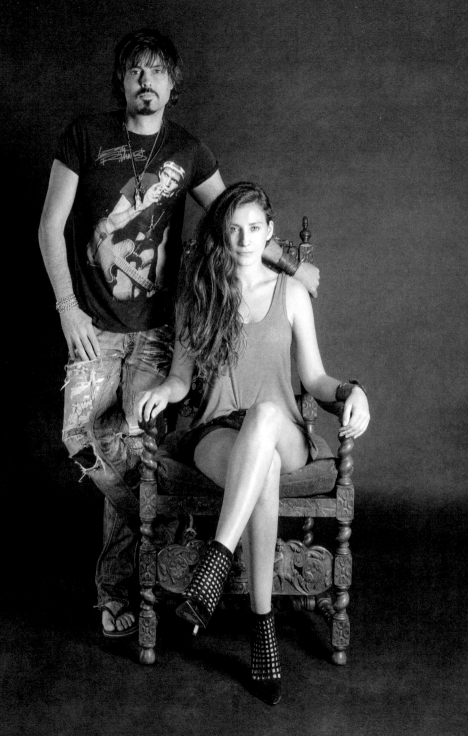

RICK AND MELISSA CORE CABALLO

I was wanting to raise my profile and looking to have a website developed and came across Mel and Rick via Facebook. I had noticed on their page that we had similar styles and taste and that is what drew me to them. Our first project together was my website, where we compiled my history, did a new photo shoot, and built everything from scratch.

During that process Mel and Rick suggested I should consider writing a book. I explained that I had been down that road but had decided not to do it after having met with many publishers in New York. It seemed like it would take years to put together an autobiography and it didn't feel like a good fit for me. I always thought that if I did a book, it would be a coffee table book, with me telling my story through pictures. To me, that would be way cooler anyway. Mel and Rick got me a publishing deal to do just that, and I had to put up or shut up.

What I love about their company, Dead Horse Branding, is that they do everything in-house. Rick is the creative side and Mel is the management side.

I have always said you need a great team to succeed and have fun. If this new chapter of my life is as successful as my first chapter, I am buying a Porsche Cabriolet.

"It doesn't matter if you're a musician, waiter, valet driver, or a hair stylist, Tony has most likely made an impact on your life and career."

Rick Caballo

"Looking back on Tony Brown's history and the people he's worked with, it's such an honor to not only put his book project together but work with him daily on all of his projects. There are not many people in the world you would call chosen family."

Melissa Core Caballo

At NAMM TEC Tracks Sessions in Nashville in (2017).

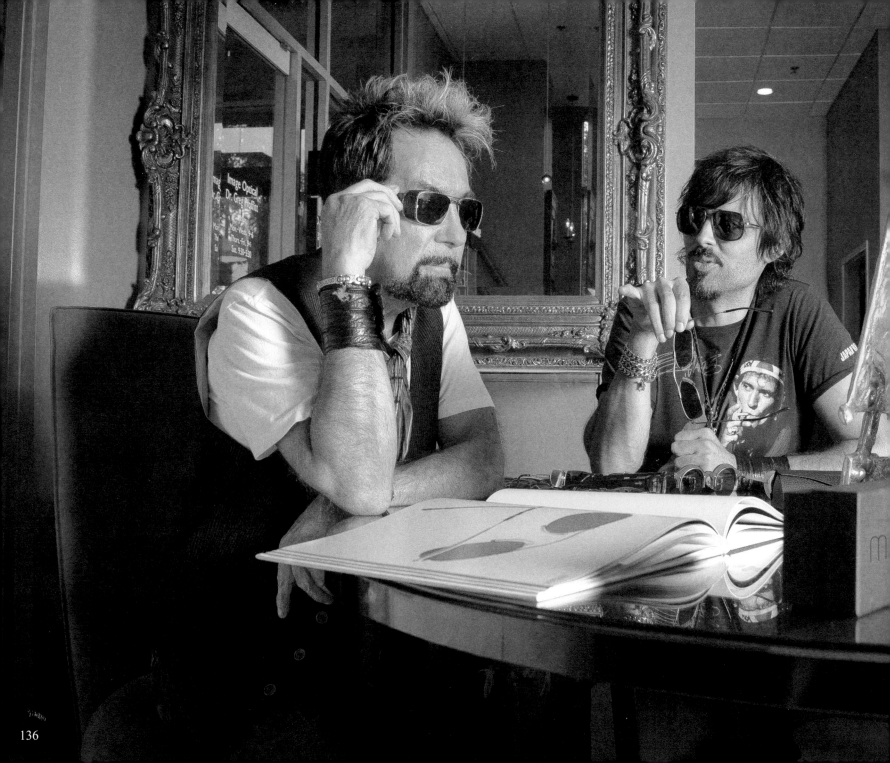

Sunglasses are part of my thing and I don't feel sufficiently dressed without my cool Matsuda eyewear.

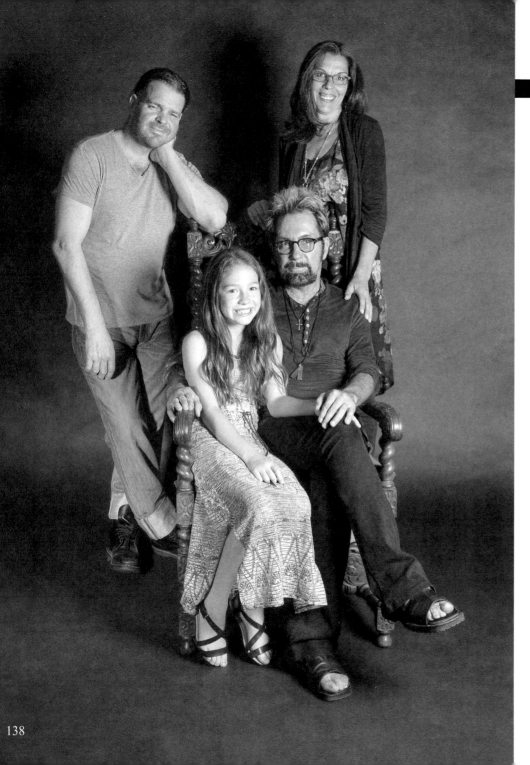

FAMILY

My son and daughter, Brennan and Brandi, moved to Colorado when they were two and three years old after their mother and I divorced. As young adults they moved back to Nashville, where Brandi would have my first grandchild, Josie.

Brennan was a BMX rider whose high skill level earned him a team sponsorship. He is now an executive chef in Australia at a restaurant where he used to be just a cook. Neither child would follow my path in the music business.

I am extremely proud of Brennan and Brandi for carving out their own identities, yet still participating in my world by attending different music events that involve me.

Young Josie Brown, however, seems to have the music and entertainment bug and is taking piano lessons, dance classes, and even drum lessons. Her middle name is Gibson, and although she hasn't picked up a guitar yet, it's still early! After all the years of ups and downs, our bond is stronger than ever!

"My dad....he is joy, he is heart and soul that is so gentle and deep. He has inspired me to always follow my heart and live from my heart." *Brandi Brown*

FAMILY IS EVERYTHING!

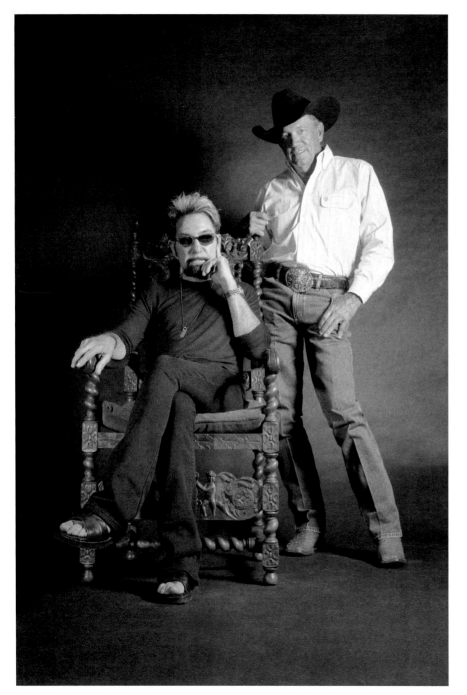

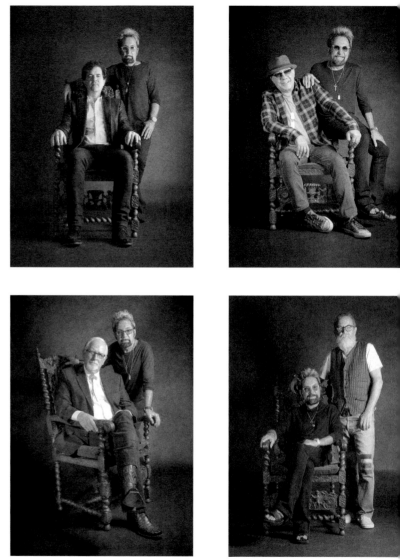

George Strait: **A COWBOY. AND THE RODEO**

140

COWGIRL. THAT'S PURE COUNTRY. Reba McEntire

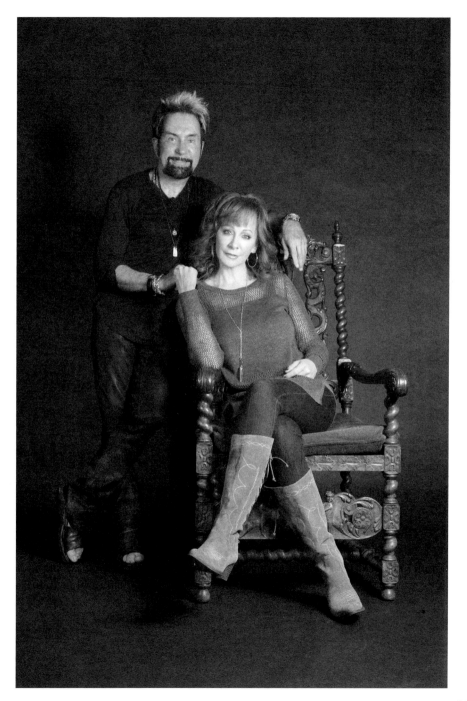

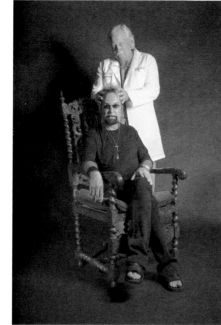

Me during the Cyndi Lauper sessions at Sound Emporium Recording Studio in Nashville.

2015

In 2015 Cyndi Lauper came to Nashville with iconic music executive Seymour Stein to meet with producers who she might work with on a concept album that would include songs from the 1940s to 1960s.

Cyndi met with every producer in town who had experience working on a wide range of country songs, and when she settled on working with me, I was thrilled!

The album, called *Detour*, was not meant to garner hit radio singles but to be a critical achievement. It just had to be authentic and freaking good so that the critics wouldn't think we were being slackers doing half-assed covers.

Cyndi's longtime studio engineer, William Wittman, worked on the project with us and brought a lot to the table. From the first song we cut, I realized that Cyndi doing classic country covers was going to be a challenge, but in a good way. By that I mean that she's a stylist with a very distinct pop sound. Nonetheless, it translated perfectly. Some people think of Cyndi as the chick with pink hair—and I found out she's a woman with an amazing voice. Vocally, she really has no limits.

"I really wanted a partner I could co-produce with who I thought understood where I was going with this album, and Tony seemed the easiest to talk to."

Cyndi Lauper

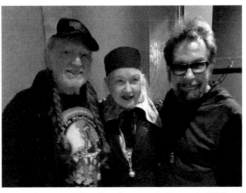

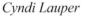

Photos from recording Cyndi Lauper's *Detour* in 2015 at Sound Emporium Studios in Nashville, featuring Cyndi with me, Willie Nelson, William Wittman, Emmylou Harris, and Vince Gill.

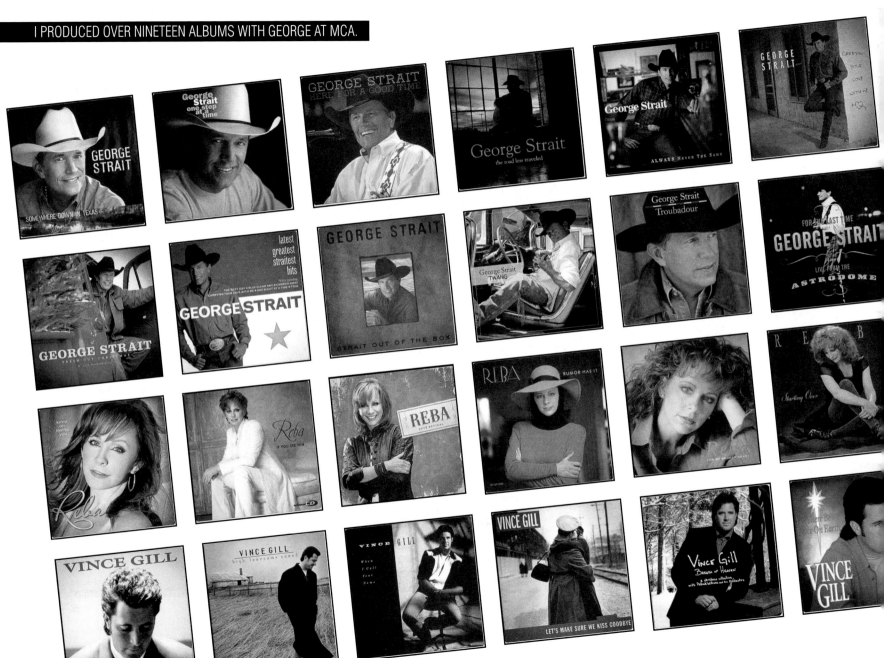

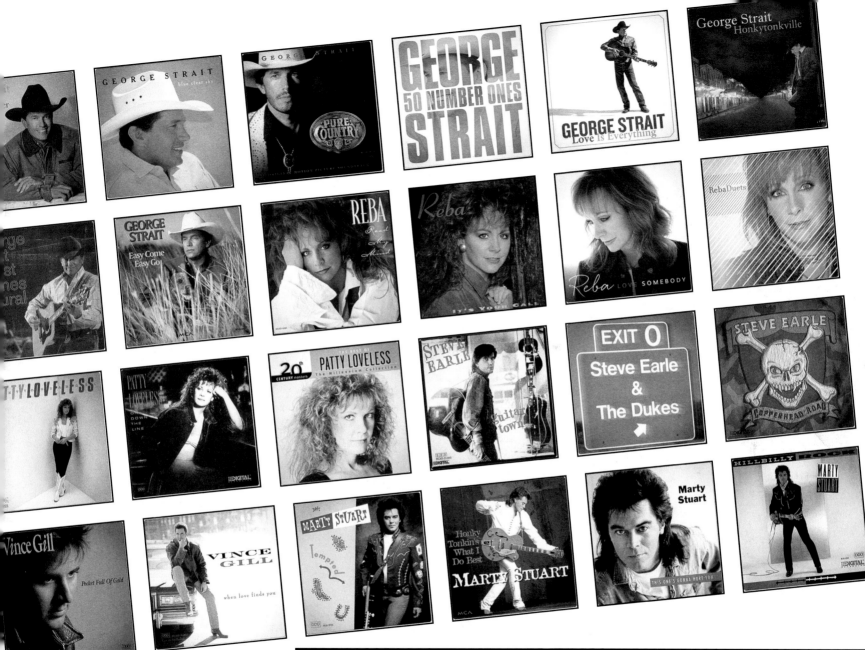

AND OVER TWELVE ALBUMS WITH REBA MCENTIRE AT MCA: THE BEST EXAMPLE OF MY BODY OF WORK.

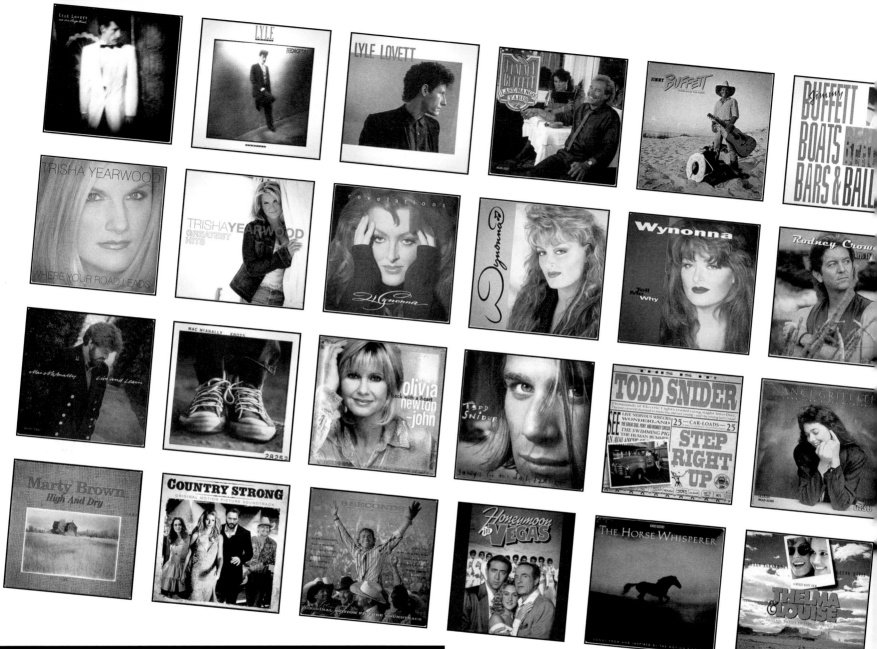

I PRODUCED ALBUMS FOR ARTIST FROM CYNDI LAUPER TO BILLY JOEL,

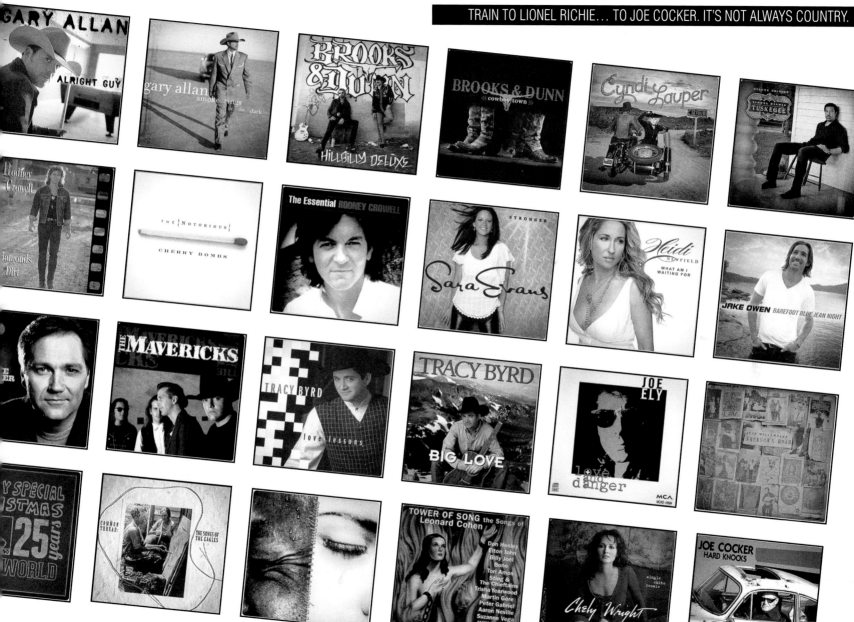

151

THE STUDIO HAS BECOME **MY STAGE**, AS I AM NO LONGER A TOURING **MUSICIAN.**

I NOW GET TO LIVE THROUGH THE **MUSICIANS** AND **ARTISTS** AS THEY LAY DOWN THE TRACKS.

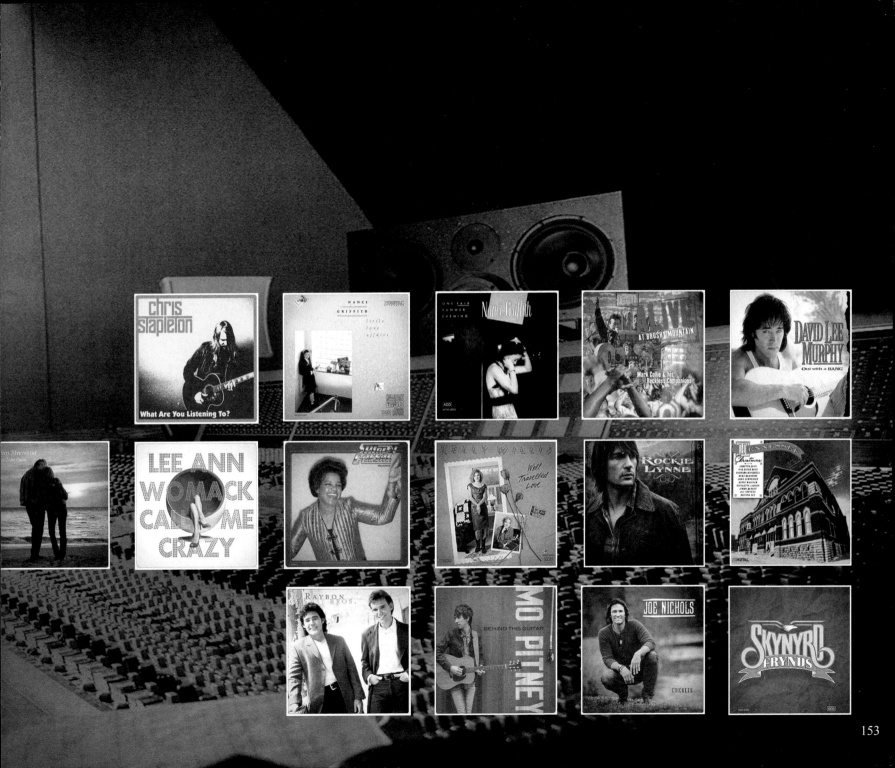

153

I NEVER WANTED TO BE FAMOUS....

GRAMMY AWARDS

2008 Album of the Year (Production)—*Troubadour*–MCA–George Strait

CMA AWARDS

2008 Single of the Year (Production)—"I Saw God Today"–MCA–George Strait
2007 Album of the Year (Production)—*It Just Comes Natural*–MCA–George Strait
2006 Single of the Year (Production)—"Believe"–Arista Nashville–Brooks & Dunn
1997 Album of the Year (Production)—*Carrying Your Love with Me*–MCA–George Strait
1996 Single of the Year (Production)—"Check Yes or No"–MCA–George Strait
1996 Album of the Year (Production)—*Blue Clear Sky*–MCA–George Strait
1994 Album of the Year (Production)—*Common Thread: The Songs of the Eagles*–MCA–Giant
1993 Album of the Year (Production)—*I Still Believe in You*– MCA–Vince Gill
1990 Single of the Year (Production)—"When I Call Your Name"–MCA–Vince Gill

ACM AWARDS

2008 Producer of the Year
2006 ACM Vocal Event—"Building Bridges"–Arista–Brooks and Dunn with Sheryl Crow
2006 Single Record of the Year—"Give It Away"–MCA–George Strait
2003 Producer of the Year
1997 Album of the Year—*Carrying Your Love with Me*–MCA–George Strait
1996 Album of the Year—*Blue Clear Sky*–MCA–George Strait
1995 Single Record of the Year—"Check Yes or No"–MCA–George Strait

AMERICANA MUSIC ASSOCIATION

2008 Lifetime Achievement Award for Producer/Engineer

....I JUST WANTED TO BE NOTICED.

TNN AWARDS

2001 Single of the Year—"Murder on Music Row"–MCA–George Strait and Alan Jackson
2000 Album of the Year—*Always Never the Same* –MCA–George Strait
2000 Single of the Year—"Write This Down"–MCA–George Strait

GRAMMY AWARD WINNING SONGS

1997 Best Male Country Vocal Performance—"Pretty Little Adriana"–MCA–Vince Gill
1995 Best Male Country Vocal Performance—"Go Rest High on That Mountain"–MCA–Vince Gill
1998 Best Male Country Vocal Performance—"If You Ever Have Forever in Mind"–MCA–Vince Gill
1997 Best Female Country Vocal Performance—"How Do I Live"–MCA–Trisha Yearwood
1996 Best Country Collaboration with Vocals—"High Lonesome Sound"–MCA–Vince Gill with Alison Krauss and Union Station
1995 Best Male Country Vocal Performance—"Worlds Apart"–MCA–Vince Gill
1989 Best Country Vocal Performance—MCA/Curb–Lyle Lovett and His Large Band–Lyle Lovett
1985 Best Female Soul Gospel Performance—"Martin"–Word–Shirley Caesar
1983 Best Soul Gospel Performance by a Duo or Group—"I'm So Glad We're Standing Here Today"-WMG–Bobby Jones & New Life with Barbara Mandrell

OTHER AWARDS

2013 Inducted into the North Carolina Music Hall of Fame
2009 The Cecil Scaife Visionary Award
2004 Leadership Music Dale Franklin Leadership Award
1997 International Achievement in Arts Awards—Pioneer Award for Distinguished Achievement in the Recording Industry: Country Crossover Music
1997 Recognized by Nashville Business in list of 100 Most Powerful
1997-1995 Nashville Music Awards—Outstanding Producer
1995 TEC Awards (Technical Excellence & Creativity)—Outstanding Creative Achievement–Record Producer
1972 Gospel Music Association—Best Gospel Instrumentalist

MUSIC PRODUCTIONS

ARTIST	ALBUM	RELEASE YEAR/LABEL	PRODUCER
Tim Krekle	*Crazy Me*	1979/Capricorn	Tony Brown
Shirley Caesar	*Rejoice*	1980/Word	Tony Brown
Steve Wariner	*Midnight Fire*	1983/RCA	Tony Brown
	One Good Night Deserves Another	1985/MCA	Tony Brown/Jimmy Bowen
	Life's Highway	1985/MCA	Tony Brown/Jimmy Bowen
	It's a Crazy World	1987/MCA	Tony Brown/Jimmy Bowen
Jimmy Buffett	*Riddles in the Sand*	1984/MCA	Tony Brown/Jimmy Bowen
	Last Mango in Paris	1985/MCA	Tony Brown
Nicolette Larson	*Say When*	1985/MCA	Tony Brown
Lyle Lovett	*Lyle Lovett*	1986/Curb/MCA	Tony Brown/Lyle Lovett
	Pontiac	1988/Curb/MCA	Tony Brown/Lyle Lovett/Billy Williams
	Lyle Lovett and His Large Band	1989/Curb/MCA	Tony Brown/Lyle Lovett/Billy Williams
Steve Earle	*Guitar Town*	1986/MCA	Tony Brown
	Exit 0	1987/MCA	Tony Brown
	Copperhead Road	1988/MCA	Tony Brown
Nanci Griffith	*Lone Star State of Mind*	1987/MCA	Tony Brown/Nanci Griffith
	Little Love Affairs	1988/MCA	Tony Brown/Nanci Griffith
	One Fair Summer Evening	1988/MCA	Tony Brown/Nanci Griffith
Rodney Crowell	*Diamonds & Dirt*	1988/Columbia	Tony Brown/Rodney Crowell
	Keys to the Highway	1989/Columbia	Tony Brown/Rodney Crowell
	Let the Picture Paint Itself	1994/MCA	Tony Brown/Rodney Crowell
Patty Loveless	*If My Heart Had Windows*	1988/MCA	Tony Brown/Emory Gordy Jr.
	Honky Tonk Angel	1988/MCA	Tony Brown
	On Down the Line	1990/MCA	Tony Brown
Karen Staley	*Wildest Dreams*	1989/MCA	Tony Brown
James House	*James House*	1989/MCA	Tony Brown
	Hard Times for an Honest Man	1990/MCA	Tony Brown
The Bellamy Brothers	*Greatest Hits III*	1989/MCA/Curb	Tony Brown
Lionel Cartwright	*Lionel Cartwright*	1989/MCA	Tony Brown/Steuart Smith
	I Watched It on the Radio	1990/MCA	Tony Brown/Steuart Smith
	Chasin' the Sun	1991/MCA	Tony Brown

ARTIST	ALBUM	RELEASE YEAR/LABEL	PRODUCER
Marty Stuart	*Hillbilly Rock*	1989/MCA	Tony Brown/Richard Bennett
	Tempted	1991/MCA	Tony Brown/Richard Bennett
	This One's Gonna Hurt You	1992/MCA	Tony Brown/Richard Bennett
	Honky Tonkin's What I Do Best	1996/MCA	Tony Brown/Justin Niebank
Vince Gill	*When I Call Your Name*	1989/MCA	Tony Brown
	Pocket Full of Gold	1991/MCA	Tony Brown
	I Still Believe in You	1992/MCA	Tony Brown
	Let There Be Peace on Earth	1993/MCA	Tony Brown
	When Love Finds You	1994/MCA	Tony Brown
	High Lonesome Sound	1996/MCA	Tony Brown
	The Key	1998/MCA	Tony Brown
	Breath of Heaven	1998/MCA	Tony Brown
	A Christmas Collection		
	Let's Make Sure We Kiss Goodbye	2000/MCA	Tony Brown
Mark Collie	*Hardin County Line*	1990/MCA	Tony Brown/Doug Johnson
	Born and Raised in Black and White	1991/MCA	Tony Brown/Doug Johnson
	Alive at Brushy Mountain	2012/Wilbanks Ent.	Tony Brown
Kelly Willis	*Well Travelled Love*	1990/MCA	Tony Brown/John Guess
	Bang Bang	1991/MCA	Tony Brown
	Kelly Willis	1993/MCA	Tony Brown/Don Was/John Leventhal
Reba McEntire	*Rumor Has It*	1990/MCA	Tony Brown
	For My Broken Heart	1991/MCA	Tony Brown
	It's Your Call	1992/MCA	Tony Brown
	Read My Mind	1994/MCA	Tony Brown
	Starting Over	1995/MCA	Tony Brown
	If You See Him	1998/MCA	Tony Brown
	Reba Duets	2007/MCA	Tony Brown
	Keep On Loving You	2009/Valory	Tony Brown
	Love Somebody	2015/Nash Icon	Tony Brown

ARTIST	ALBUM	RELEASE YEAR/LABEL	PRODUCER
Desert Rose Band	*True Love*	1991/Curb	Tony Brown
Marty Brown	*High and Dry*	1991/MCA	Tony Brown/Richard Bennett
Joe Ely	*Love and Danger*	1992/MCA	Tony Brown
The Mavericks	*From Hell to Paradise*	1992/MCA	Tony Brown/Richard Bennett/Steve Fishell
Mac McAnally	*Live and Learn*	1992/MCA	Tony Brown
	Knots	1994/MCA	Tony Brown
McBride and the Ride	*Sacred Ground*	1992/MCA	Tony Brown/Steve Gibson
	Hurry Sundown	1993/MCA	Tony Brown/Steve Gibson
Wynonna Judd	*Wynonna*	1992/Curb/MCA	Tony Brown
	Tell Me Why	1993/Curb/MCA	Tony Brown
	Revelations	1996/Curb/MCA	Tony Brown
George Strait	*Pure Country*	1992/MCA	Tony Brown/George Strait
	Easy Come, Easy Go	1993/MCA	Tony Brown/George Strait
	Lead On	1994/MCA	Tony Brown/George Strait
	Blue Clear Sky	1996/MCA	Tony Brown/George Strait
	Carrying Your Love with Me	1997/MCA	Tony Brown/George Strait
	One Step at a Time	1998/MCA	Tony Brown/George Strait
	Always Never the Same	1999/MCA	Tony Brown/George Strait
	Merry Christmas Wherever You Are	1999/MCA	Tony Brown/George Strait
	George Strait	2000/MCA	Tony Brown/George Strait
	The Road Less Traveled	2001/MCA	Tony Brown/George Strait
	For the Last Time	2003/MCA	Tony Brown/George Strait
	Live from the Astrodome	2003/MCA	Tony Brown/George Strait
	Honkytonkville	2003/MCA	Tony Brown/George Strait
	Somewhere Down in Texas	2005/MCA	Tony Brown/George Strait
	It Just Comes Natural	2006/MCA	Tony Brown/George Strait
	Fresh Cut Christmas	2006/Hallmark	Tony Brown/George Strait
	Troubadour	2008/MCA	Tony Brown/George Strait
	Classic Christmas	2008/MCA	Tony Brown/George Strait

ARTIST	ALBUM	RELEASE YEAR/LABEL	PRODUCER
George Strait	*Classic Christmas*	2008/MCA	Tony Brown/George Strait
	Twang	2009/MCA	Tony Brown/George Strait
	Here for a Good Time	2011/MCA	Tony Brown/George Strait
	Love Is Everything	2013/MCA	Tony Brown/George Strait
David Lee Murphy	*Out with a Bang*	1994/MCA	Tony Brown
	Getting Out the Good Stuff	1996/MCA	Tony Brown
	We Can't All Be Angels	1997/MCA	Tony Brown
Todd Snider	*Songs for the Daily Planet*	1994/MCA/Margaritaville	Tony Brown/Mike Utley
	Step Right Up	1996/MCA	Tony Brown
Tracy Byrd	*Love Lesson*	1995/MCA	Tony Brown
	Big Love	1996/MCA	Tony Brown
	I'm from the Country	1998/MCA	Tony Brown
Mark Chesnutt	*Wings*	1995/Decca	Tony Brown
	Greatest Hits	1996/Decca	Tony Brown
George Jones and Tammy Wynette	*One*	1995/MCA	Tony Brown
Bobbie Cryner	*Girl of Your Dreams*	1996/MCA	Tony Brown/Barry Beckett
Chely Wright	*Let Me In*	1997/MCA	Tony Brown
	Single White Female	1999/MCA	Tony Brown
Raybon Brothers	*Raybon Brothers*	1997/MCA	Tony Brown/Don Cook
Olivia Newton-John	*Back with A Heart*	1998/MCA	Tony Brown
Kris Tyler	*What a Woman Knows*	1998/Rising Tide	Tony Brown
Trisha Yearwood	*Where Your Road Leads*	1998/MCA	Tony Brown
Alecia Elliott	*I'm Diggin' It*	2000/MCA	Tony Brown/Jeff Teague
Katrina Elam	*Katrina Elam*	2004/Universal South	Tony Brown/Jimmie Lee Sloas
The Notorious Cherry Bombs	*(self-titled)*	2004/Universal South	The Notorious Cherry Bombs
Amanda Wilkinson	*Amanda Wilkinson*	2005/Universal South	Tony Brown

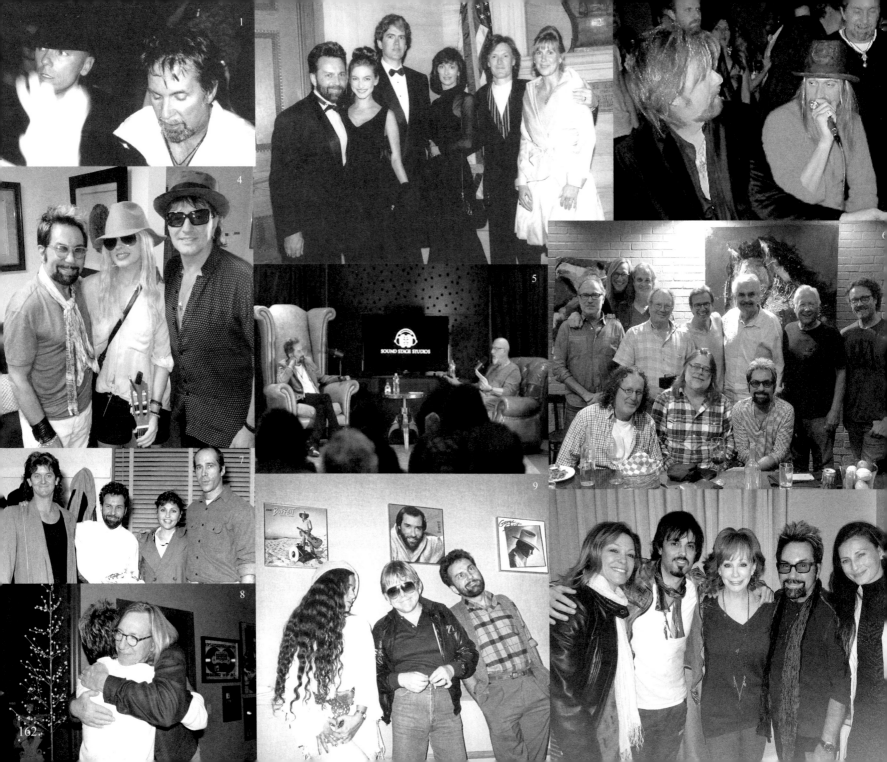

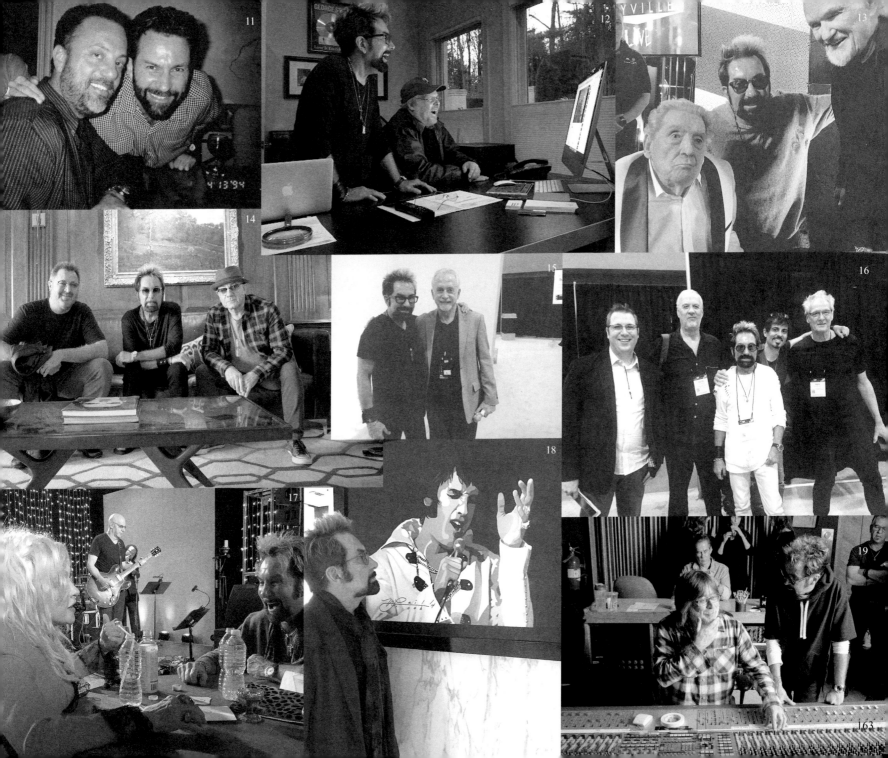

163

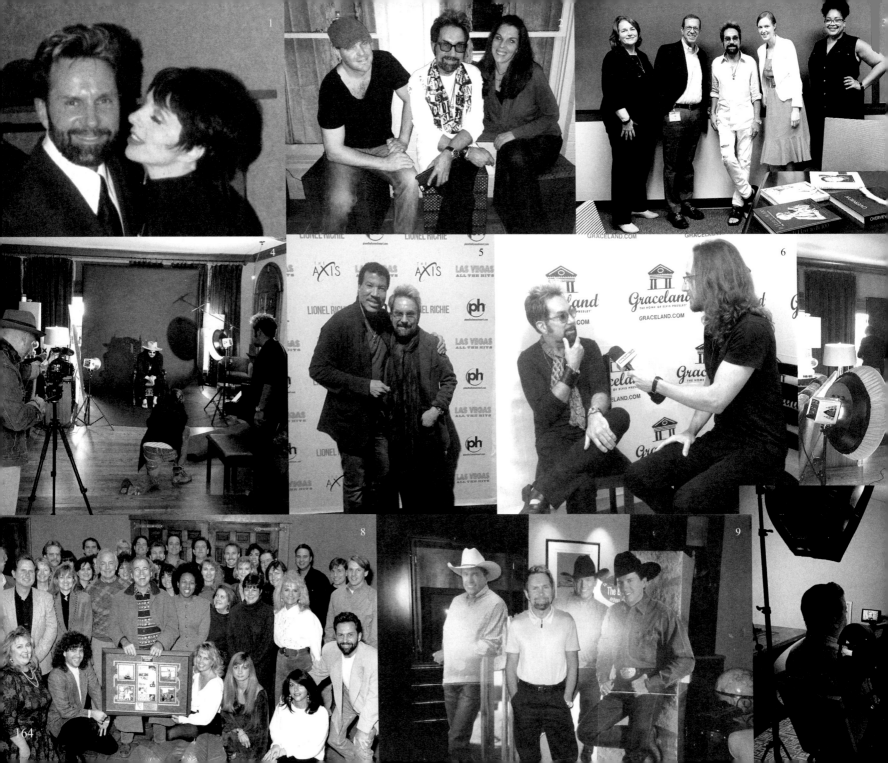

11

12
JUNE 12TH 1996
TONY BROWN RECLUSE
EXIT/ IN 10 P.M.
Doors open at 9 p.m.

13
STUDIO CITY

14
STEVE EARLE

Elvis IN CONCERT

15

16

17

18

19

20
TCB

21
DISCO TONY!

1997 Quarterly - St. Pete Beach, FL

165

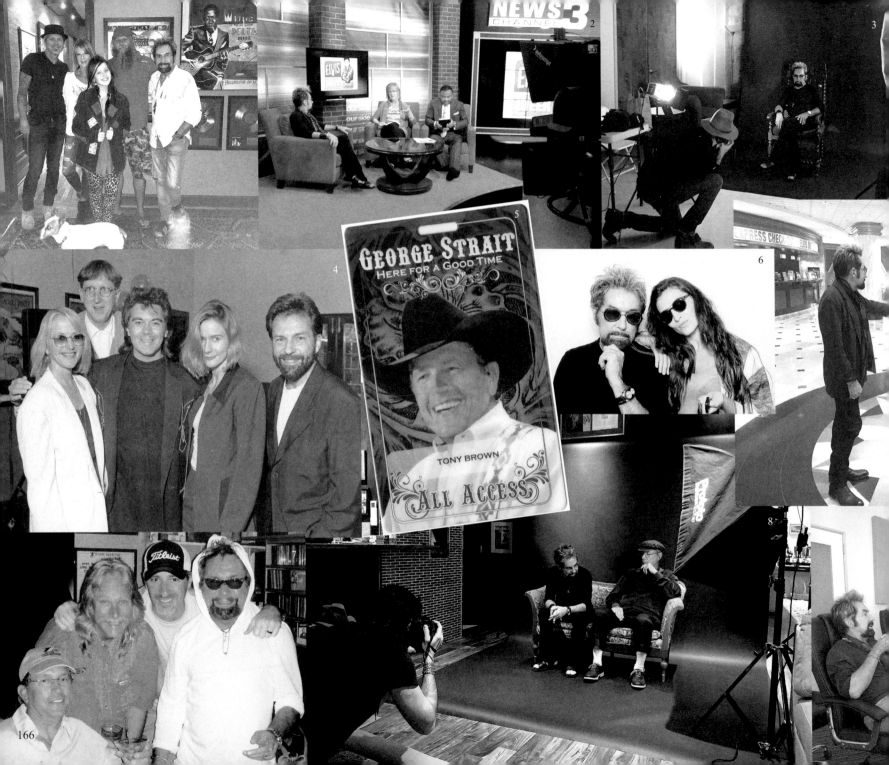

NEWS CHANNEL 3

GEORGE STRAIT
HERE FOR A GOOD TIME

TONY BROWN
ALL ACCESS

166

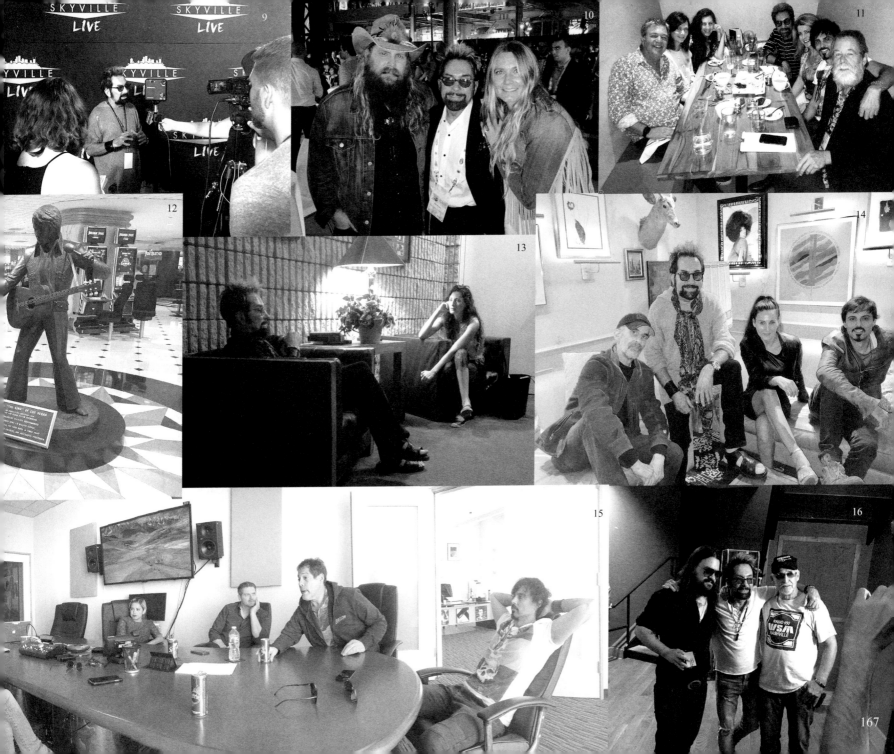

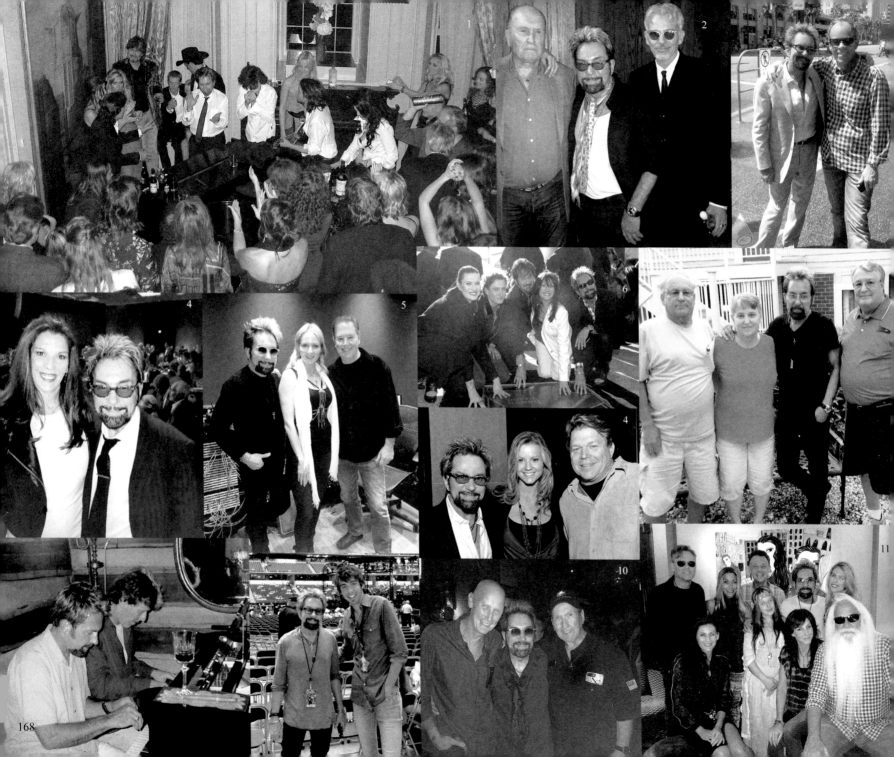

169

Technology has changed the way we record and listen to music.
But one thing it can't do is write a great song. Songs are magic that come from a higher place.

The piano has everything laid out in front of you with no constraints.
Black keys, white keys, sharp notes, and flat notes—they all work together in perfect harmony!

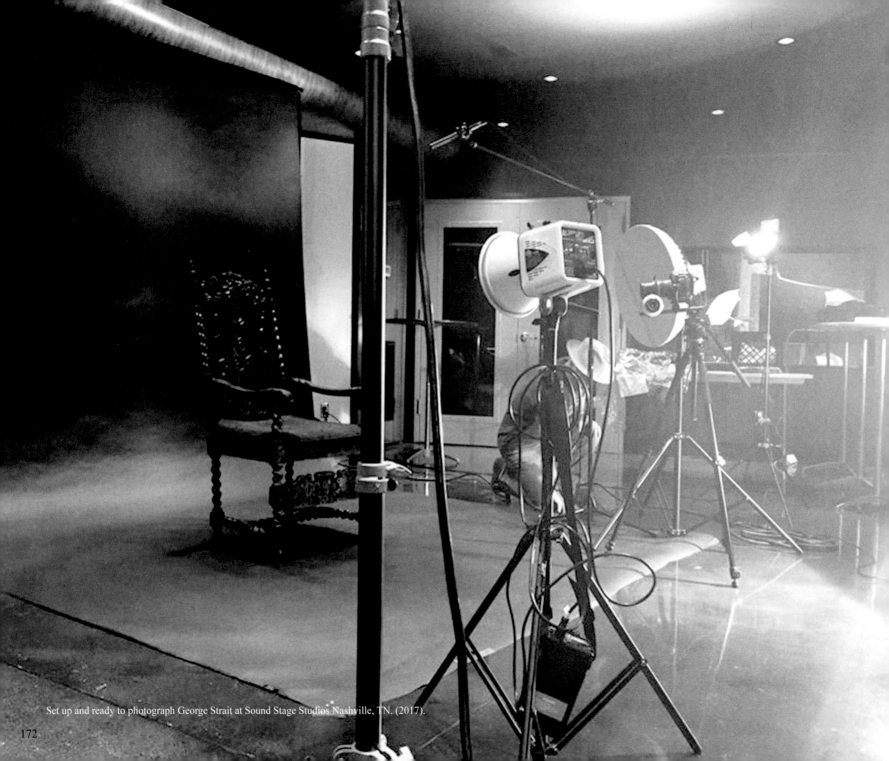

Set up and ready to photograph George Strait at Sound Stage Studios Nashville, TN. (2017).

Page

Inside cover, Tommy Mattox

5. Debra Snell

6. Rick Caballo, Melissa Core Caballo

9. Rick Caballo, Melissa Core Caballo

10. Rick Caballo

11. Rick Caballo, Melissa Core Caballo

12-19. Brown Archives

20. Brown Archives (top 3 photos from l); Suzan Speer (top far r); Donnie Sumner (bottom)

21. Brown Archives (top); Donnie Sumner (bottom)

22. Pete Mroz

23. Donnie Sumner (l); Pete Mroz (r)

24. Rick Caballo, Melissa Core Caballo

25. Donnie Sumner; Rick Caballo, Melissa Core Caballo (bottom 3rd and 5th from l)

26. Rick Caballo, Melissa Core Caballo

27. Jimmy Moore (top); Brown Archives (bottom l); BMI (bottom r)

28. Rick Caballo, Melissa Core Caballo

29. Alan Mayor (top); Brown Archives (bottom)

30. Rick Caballo, Melissa Core Caballo

31. Brown Archives

32-33. Rick Caballo, Melissa Core Caballo

36-37. Keith Allverson

38-39. Brown Archives

40-41. Rick Caballo, Melissa Core Caballo (top and bottom l); Brown Archives (r)

43. Brown Archives

44-46. Rick Caballo, Melissa Core Caballo

47. Brown Archives (r); Joe Horton (l)

48. Rick Caballo, Melissa Core Caballo

49. Brown Archives

50. Rick Caballo, Melissa Core Caballo

51. Brown Archives

52-54. Rick Caballo, Melissa Core Caballo

55. Brown Archives

56. Rick Caballo, Melissa Core Caballo

57. Getty Images

58. Rick Caballo, Melissa Core Caballo

59. Brown Archives

60. Rick Caballo, Melissa Core Caballo

61. Alan Mayor

62. Rick Caballo, Melissa Core Caballo

63. Brown Archives (top row and bottom l); Tanda Paine (bottom c and r)

65-66. Rick Caballo, Melissa Core Caballo

67. Brown Archives

68. Rick Caballo, Melissa Core Caballo

69. Rick Caballo, Melissa Core Caballo (top l); Brown Archives (top r, bottom row)

70. Rick Caballo, Melissa Core Caballo

71. Brown Archives (top l and c); Beth Gwinn (top r); Tirk Wilder (bottom l); Rick Caballo, Melissa Core Caballo (bottom r)

72. Rick Caballo, Melissa Core Caballo

73. Rick Caballo, Melissa Core Caballo (top); Brown Archives (bottom)

74. Rick Caballo, Melissa Core Caballo

75. Brown Archives (l); Beth Gwinn (r)

76. Rick Caballo, Melissa Core Caballo

77. Brown Archives (top l), Beth Gwinn (top r); Brown Archives (bottom l); Getty Image (bottom r)

78. Rick Caballo, Melissa Core Caballo

79. Beth Gwinn

80-86. Rick Caballo, Melissa Core Caballo

87. Brown Archives

88. Rick Caballo, Melissa Core Caballo

89. Brown Archives

90. Rick Caballo, Melissa Core Caballo

91. Alan Mayor (top l); Getty Images (top r); Brown Archives (bottom l); Beth Gwinn (bottom r)

92. Rick Caballo, Melissa Core Caballo

93. Beth Gwinn (top l); Tanda Paine (top r); Brown Archives (bottom l), Beth Gwinn (bottom r)

94-96. Rick Caballo, Melissa Core Caballo

97. Brown Archives

98. Rick Caballo, Melissa Core Caballo

100-101. 1., 4-5., 7-10. Brown Archives; 2., 6. NJNYC; 3. Richard Criton

102. Rick Caballo, Melissa Core Caballo

104. Rick Caballo, Melissa Core Caballo

105. Brown Archives (top l); Rick Caballo,

Melissa Core Caballlo (top and bottom r, center); Getty Images (bottom and center l)

106. Rick Caballo, Melissa Core Caballo

107. Beth Gwinn (top l); Brown Archives

108. Rick Caballo, Melissa Core Caballo

109. 1-2. Beth Gwinn; 3-4. Brown Archives; 5. Tommy Mattox

110. Rick Caballo, Melissa Core Caballo

111. Brown Archives

112. Beth Gwinn

113. Tanda Paine

114. Rick Caballo, Melissa Core Caballo

115. Craig Robert Dietz (top); Brown Archives (bottom l); Tanda Paine (bottom r)

116. Rick Caballo, Melissa Core Caballo

117. Rick Caballo, Melissa Core Caballo (l); Brown Archives (r)

118. Rick Caballo, Melissa Core Caballo

122. Brown Archives

124. Rick Caballo, Melissa Core Caballo

125. Brown Archives; Rick Caballo, Melissa Core Caballo (bottom r and c)

126. Rick Caballo, Melissa Core Caballo

127. Brown Archives

128. Rick Caballo, Melissa Core Caballo

129. Brown Archives

130. Dirk Vanoucek, Rick Caballo, Rick Caballo, Melissa Core Caballo

131. Alan Silfen

133-134. Rick Caballo, Melissa Core Caballo

135. Brown Archives

136-138. Rick Caballo, Melissa Core Caballo

139. Brown Archives; Rick Caballo, Melissa Core Caballo (center r)

140-144. Rick Caballo, Melissa Core Caballo

145. Amy Garges; Melissa Core Caballo (top r)

146-153. Brown Archives

152. Rick Caballo, Melissa Core Caballo

154. Tommy Mattox

155. Getty Images

162. 1., 3-4., 6., 9. Brown Archives; 2. Joe Horton; 5. Tirk Wilder; 7. Beth Gwinn; 8. Rick Caballo, Melissa Core Caballo

163. 11. Brown Archives; 12-15., 17-19. Rick Caballo, Melissa Core Caballo; 16. Melissa Core Caballo

164. Brown Archives

165. 11-14., 16-17., 20-21. Brown Archives; 15., 18. Melissa Core Caballo; 19. Rick Caballo, Melissa Core Caballo

166. 1-3., 6., 8. Melissa Core Caballo; 4., 7. Brown Archives; 5. Rick Caballo, Melissa Core Caballo

167. 9-12. Rick Caballo, Melissa Core Caballo; 10. Amy Garges; 11., 14. Brown Archives; 13. Rick Caballo; 15-16. Melissa Core Caballo

168. 1. NJNYC; 2-4., 7-8. Brown Archives; 5., 9. Amy Garges; 6. Getty Images; 9 10.,11. Rick Caballo

169. 12. Dirk Vanoucek; 13., 15-19. Brown Archives; 14. Getty Images; 20-21. Rick Caballo, Melissa Core Caballo;

170-175. Rick Caballo, Melissa Core Caballo

Trying to make it is more fun
than trying to sustain it!

THE AUTHOR

T O N Y B R O W N

Tony Brown's reputation as an unshakeable pillar of country music spans forty years. As an acclaimed record producer, the co-founder of Universal South Records, and the former President of MCA Records Nashville—a title he held for nearly a decade—Tony has worked with some of the biggest names in music. Having produced numerous hits by artist like George Strait, Reba McEntire, and Vince Gill, Tony is still one of the most sought-after and revered producers around.

Often credited with founding the Americana country movement, Tony was never afraid to push the envelope. He has proven the power of bending genres, helping establish the legendary careers of Steve Earle and Lyle Lovett, among others in the Americana format.

Tony has earned several awards and recognitions for his achievements, including a Grammy award, seven Academy of Country Music awards, including Producer of the Year, multiple CMA awards, and he has many gold, platinum, and multi-platinum album credits.

Over the course of his monumental career, Tony has yielded over 100 number one singles and record sales exceeding 100 million units, while simultaneously helping build the careers of a pantheon of stars, unparalleled in music history. Some of the artists Tony signed to record deals include Trisha Yearwood, Patty Loveless, Marty Stuart, Rodney Crowell, Joe Ely, Kelly Willis, Todd Snider, Allison Moorer, the Mavericks, Shooter Jennings, and many more.

Tony also produced most of the tracks on Lionel Richie's Tuskegee, one the highest grossing albums in 2012, which features Lionel's duets Blake Shelton, Jason Aldean, Darius Rucker, Tim McGraw, Jimmy Buffett, Little Big Town, Kenny Rogers, and Willie Nelson.

Tony is currently the head of Tony Brown Enterprises. He recently appeared in Dave Grohl's television docuseries, Sonic Highways. Other recent successes include producing Reba McEntire's 2015 album Love Somebody, producing Cyndi Lauper's acclaimed album, Detour, and producing Sara Evans' number one single, "A Little Bit Stronger."